The Tao of Watercolor

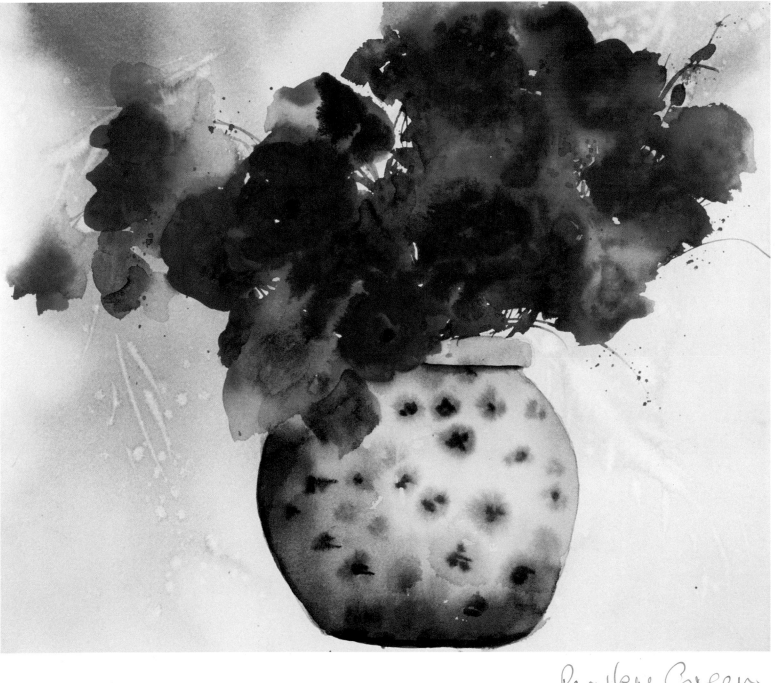

Perylene Green

The Tao of Watercolor

A Revolutionary Approach to the Practice of Painting

Jeanne Carbonetti

WATSON-GUPTILL PUBLICATIONS/NEW YORK

*To all my teachers and students,
from whom I have learned the Tao.*

Front cover
WATER WITH LILIES
22 × 30" (56 × 76 cm), 1987. Collection of the artist.

Frontispiece
ANNIE'S ENGLISH VARIETY
14 × 14" (36 × 36 cm), 1997. Private collection, Nebraska.

Title page
LILY POND
22 × 30" (56 × 76 cm), 1987. Collection of Mr. and Mrs. P. Abdeely

Contents page
IRIS GARDEN (DETAIL)
30 × 22" (76 × 56 cm), 1996. Collection of the artist.

ABOUT THE AUTHOR

Jeanne Carbonetti, whose watercolors are in many North American and European collections, instructs creative-process workshops and teaches private and group classes in drawing and painting. She lives in Chester, Vermont, where she owns Crow Hill Gallery and Art Center.

Edited by Robbie Capp
Designed by Areta Buk
Graphic production by Hector Campbell
Text set in 11.5 Adobe Caslon

First published in 1998 by Watson-Guptill Publications,
Nielsen Business Media, a division of The Nielsen Company
770 Broadway, New York, NY 10003
www.watsonguptill.com

Library of Congress Cataloging-in-Publication Data
Carbonetti, Jeanne.
 The Tao of watercolor : a revolutionary approach to the practice
of painting / Jeanne Carbonetti.
 p. cm.
 Includes bibliographical references and index.
 ISBN - 13 : 978-0-8230-5057-4
 ISBN 0-8230-5057-2
 1. Watercolor painting—Technique. 2. Watercolorists—Psychology.
3. Self-perception. 4. Lao-tzu. Tao te ching. I. Title.
ND2420.C35 1998
751.42'2—dc21 97-47316
 CIP

Printed in Korea

First printing, 1998

13 14 15 16 17 18 / 14 13 12 11 10 09 08

Acknowledgments

Like a pebble thrown in the water, this book has touched, and been touched by, the lives of many. It is, itself, a wonderful example of our connectedness within the great scheme of things, for its final form depended on the gifts of expertise from several different worlds. I am indebted to them all.

To Jennifer Snide and Henry Hammond for their understanding of computer language and graceful acceptance of my handwriting.

To George Leisey and Steve Yadzinsky for their patient and skillful work in the photography of this book's images.

To my agent, Claire Gerus, for her strong belief in my work and for doing her job so well.

To Candace Raney, senior editor at Watson-Guptill Publications, for her clear perceptions and vision for this book, which made my life easier and the book better.

To editor Robbie Capp, designer Areta Buk, and the many hands at Watson-Guptill who cradled this book like a baby and loved it into being.

And to my husband, Larry, who wholeheartedly embraced all the changes in our lives that this book, and my work as an artist, have invited. He remains my greatest partner in learning the Tao.

And to the source from which the Tao flows.

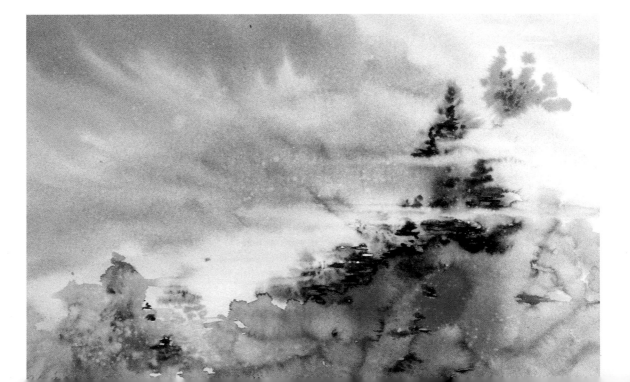

EVERGREENS IN WINTER MIST
22 × 30" (56 × 76 cm), 1987.
Private collection, Long Island,
New York.

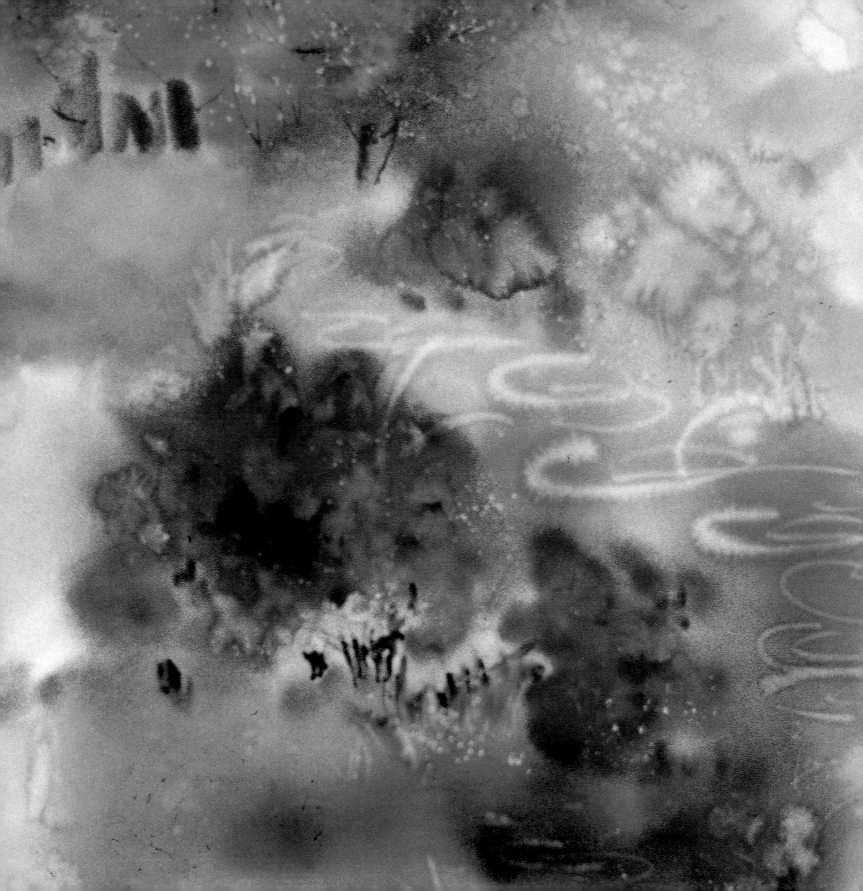

Table of **Contents**

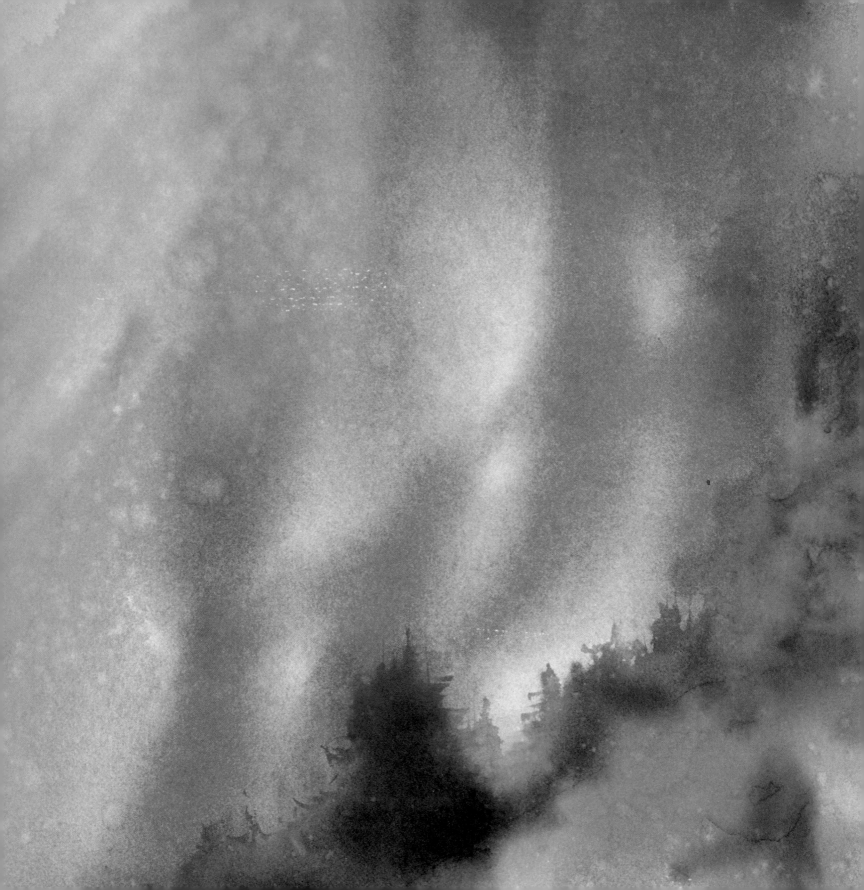

The Meaning of the Tao

Throughout this book, you will find quotes derived from the book *Tao-te Ching*, or Way of Life, ascribed to the sixth-century Chinese philosopher Lao-tzu and others. The meaning of the Tao, to me, is the essence of life. It is the meaning behind all meanings, and the One Truth that is the ground of our being. I believe that this truth, taught by all the great sacred texts, is that everything is one, that all is part of the whole, and each piece, therefore, is valid. But the only way to experience this oneness is to become one with our own selves.

When I was a child, I was whole. I simply painted, and I was glad. Later, as life grew more complex, I split into many selves, and I learned to judge them all. Some parts were good, others bad. Some were to be loved, others to be rejected. I judged my paintings, too, and myself as a painter. I became something else.

But later still, in the quiet of a time when I was too tired to judge and weak enough to listen, I painted again, and then I saw that all the mistakes, failed efforts, and bad paintings had brought me to a new place—the breakthrough painting of my first major series. My life changed that day, and I became one self again.

For painting had taught me the Tao.

TUSCANY RAIN (DETAIL)
22 × 30" (56 × 76 cm), 1997.
Collection of the artist.

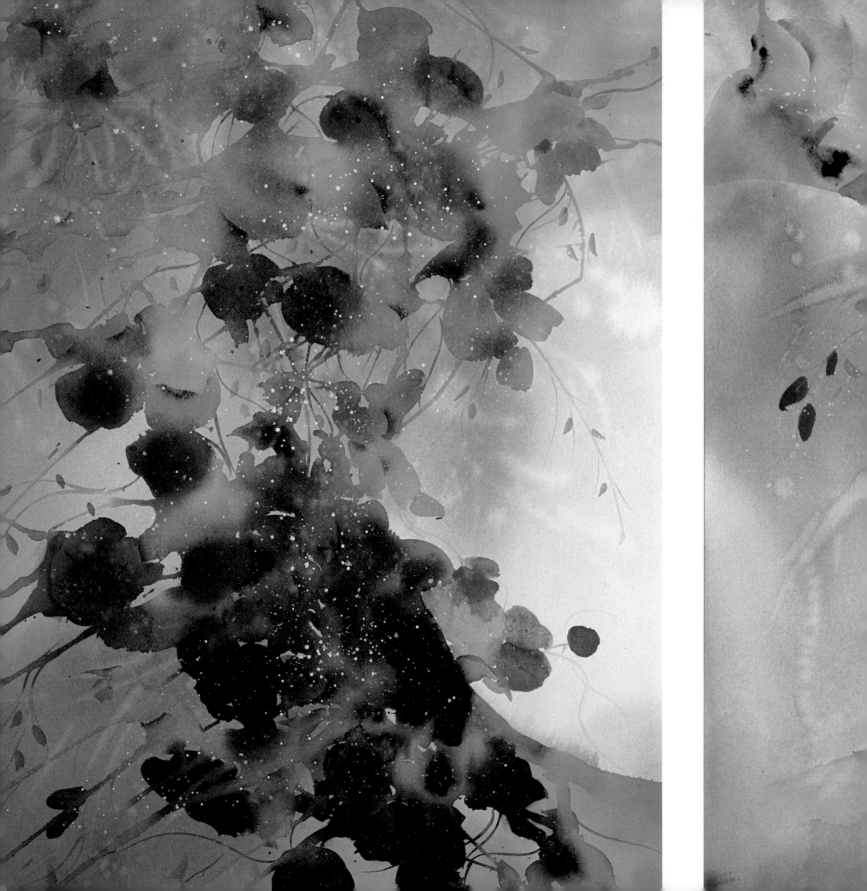

action:

Mind

The way to do is to be.

Tao-te Ching

e **Moon**
112 cm), 1996.
of the artist.

The Tao of Watercolor began, as most of the special moments in my life have begun, with a beautiful question: How does one bridge the gap between play and work, between the joy of spontaneous expression and the careful, necessary decision-making that all too soon becomes drudgery and hard labor? The synthesis of these opposites seems to me to be of great value, not just in painting, but in life as well.

This question arose over my many years of painting and working with students. I noticed time and again that students seemed to fall into two categories. One group loved to play with techniques, delighting in luscious washes, marveling at the glow of transparent color on white paper, and, of course, loving the flow. These people were all natural watercolorists (you can spot us in an instant—we're the ones who love the spills), but when it came to bringing the painting to fruition, they just couldn't cross the line that led to decision-making. They thought it stopped the creative flow and dampened the joy, so they seldom finished a painting unless the work had somehow managed to finish itself through happenstance.

The other group of students were, above all, serious painters. They wanted to express something to someone, usually tried to sell their work, and were determined to use every element of visual language available to get their point across. They became well practiced in technique, laboring over the arrangement of values and "fixed" parts of paintings with glazes, and *always* they would bring the painting to completion. However, the process exhausted them and they would ask, "Now that I know so much, why is it still so hard?"

From the age of three when I first took brush in hand and painted the living room rug, I have danced between the two worlds these students have known. Being both verbal and visual, left-brained and right-brained (though I lean toward the right), I know the benefits and frustrations of each. To be sure, both worlds have their gifts. One has the power of natural expression, without which there is no life in a piece of art. The other has the power of technical skill, which always shows, and without which the message would be lost.

In my own evolution as an artist, I have known both sides, but I seem to have arrived at a third. My first stage was characterized by my being enchanted by the medium and having it control me, much like the first group of students I spoke of earlier. After keeping at it for years and learning the craft of watercolor, I started to gain control of the medium, then overpowered it, making it do just what I wanted it to do for me.

Finally, only a short time ago, I crossed another threshold. Now I am at the beginning of a marriage between a painter and her medium—a playful partnership, and yet I'm not just playing. It is a craft, but it doesn't feel like work. Now I take play seriously. This stage encompasses both of the other worlds and gives each its proper place in the process.

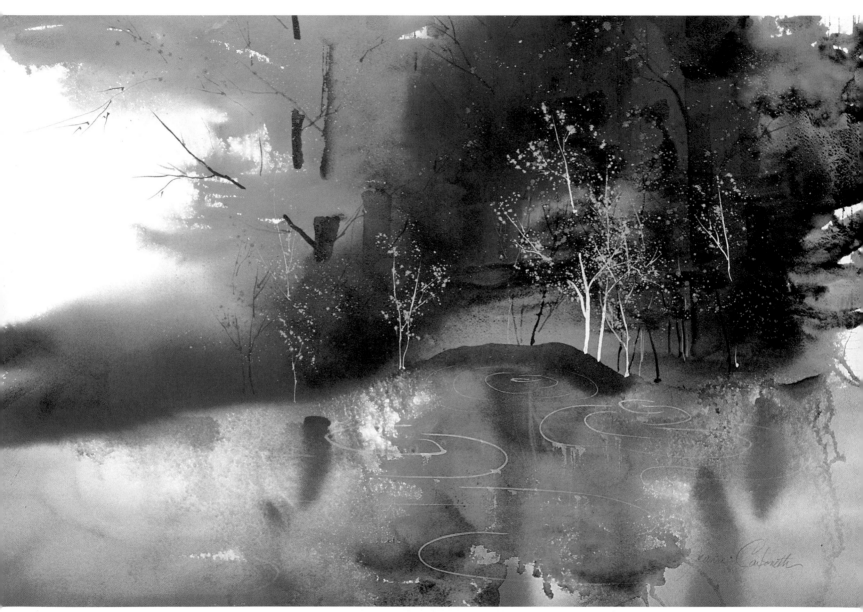

WASHINGTON SPRING
22 × 30" (56 × 76 cm), 1995.
Collection of the artist.

What was it that allowed me to make that transition to this third way of painting that brings together play and work into a new synthesis? My wish has been to find the pattern behind all of that evolution and put it into a form that can help students to come to this beautiful place a little easier, a little sooner. My dream has been to give some of that glorious, spontaneous freedom to those who have labored so, and bestow a bit of firm decision-making power on those who have been afraid to state boundaries.

The answer came just as it always does—suddenly, but quietly, and just as if it had been there all along. That is the great secret of the creative process. It is there already; we just have to be quiet enough to hear it. What came to me was that I had managed to move to a place that was beyond the opposites of left brain/right brain, craft and play, because I had reached for the place that encompassed both at once. The reaching was my own spiritual quest, and the quest was to know my own spirit.

In that lovely flash of insight, I saw that I had been drawn to watercolor painting for the same reason that I had been drawn to the Eastern arts of Sumi-e (Japanese for "pictures with ink"), Yoga, and especially Tai Chi Chuan—the ancient Chinese system of exercises based on meditative movements. They are all inner arts, and common to all is the primary concept that what is inside of us governs what we experience externally. Whether it be power, as in Tai Chi, or peace, as in Yoga and meditation, or intuitive insight, as in Sumi-e, it originates in the present moment, from within. Thus, it is that single purpose or intention— *to know oneself in the present moment*— that brings the opposites of left and right together in a common goal. Now neither one needs to take control, for each contributes to the whole in a beautiful rhythm of yin and yang, passive and active.

If I were to make a picture of this process it would look like the diagram below.

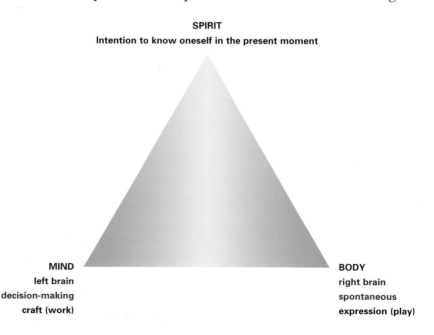

SPIRIT
Intention to know oneself in the present moment

MIND
left brain
decision-making
craft (work)

BODY
right brain
spontaneous
expression (play)

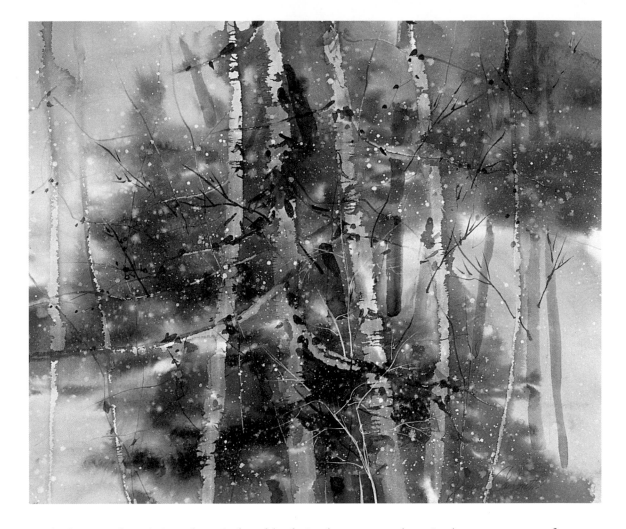

As long as there is just the mind and body in the process, there is always a seesaw of power. But as soon as there is a higher, more unifying goal, a new configuration is born, and each part of us finds its perfect purpose. Consider the difference between having the intention of making a great or salable painting or coming to self-knowledge. Given the fact that human nature needs to make mistakes in order to learn, the first intention or spirit is set up for failure already, where the second is set up for success. Not that wanting to sell a painting is a bad goal, not at all. But when it is a secondary goal to becoming a better painter, the experience changes remarkably.

That primary goal is the special attitude or spirit, an intention of self- knowledge, above all else, within the experience of painting, which turns painting into meditation and meditation into art. Like Narcissus looking into the still pool of water, we can gaze into the world of our paintings and see our own reflection, that other side of ourselves, usually hidden from view. And like Narcissus, our hearts, too, will melt into flowers, as we come to see the truth as he did: that what we have longed for we already have, that what we are already—is beautiful.

I believe that you'll gain a great deal from this book if you read it through in big chunks, then go back later for specifics. It presents a philosophical framework for viewing the practice of painting as well as a guide book of techniques to employ. I make this point because students often want to hurry to learn techniques, believing that if they just know one more method, all their paintings will then be great and the process will forever be easy. If only this were so. Painting, like life, is much more wonderfully complex. But I can tell you that all the pieces *do* fall into place; the techniques *do* become absorbed and some, even invented, as soon as you see yourself in your painting. It is then that the great dialogue with yourself begins and the true meaning of the path of painting is revealed. And it is as close as your own heart.

This book's structure goes from the general to the specific. As with the Eastern inner arts, all flows from the inner to the outer, from the spirit, through the mind, then to the body.

Divided into eight parts, each opens by presenting a quality of spirit and simple exercise to guide the painting experience, followed by a corresponding concept for decision-making, then a major technique that emanates naturally from both. Sections are augmented by practical reviews of "Things I've Learned," then conclude with step-by-step watercolor demonstrations containing specific techniques for you to practice.

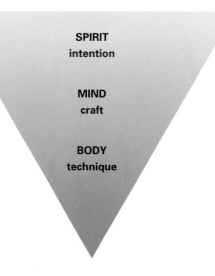

SPIRIT
intention

MIND
craft

BODY
technique

I wish you joy on your path of painting. I know that finding a form to capture what is between "in here" and "out there" is not an easy task. But it is a most worthwhile one, and as Sumi-e and Tai Chi masters and the great painters would say, it is a sacred one as well.

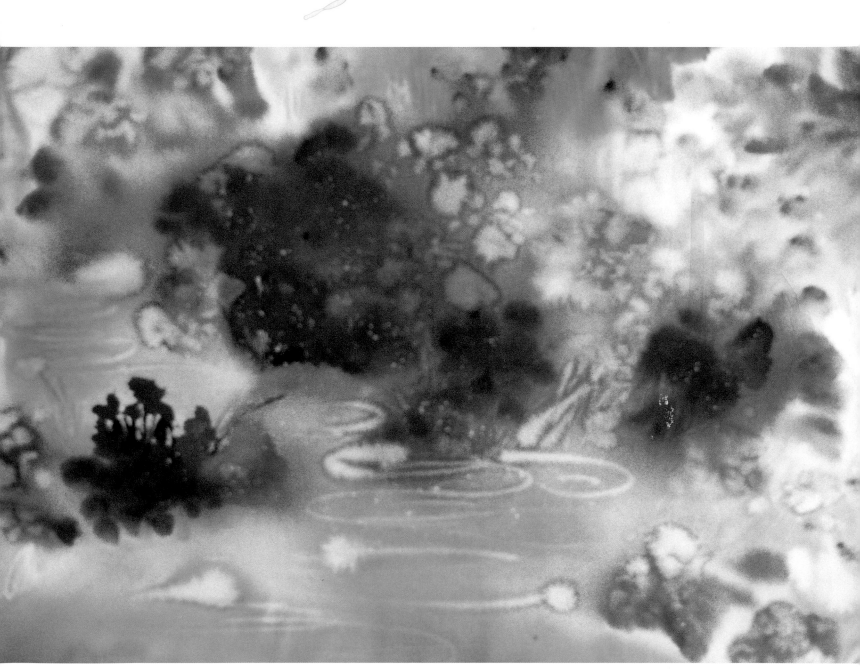

HYACINTH AND STREAM
22 × 30" (56 × 76 cm), 1996.
Collection of the artist.

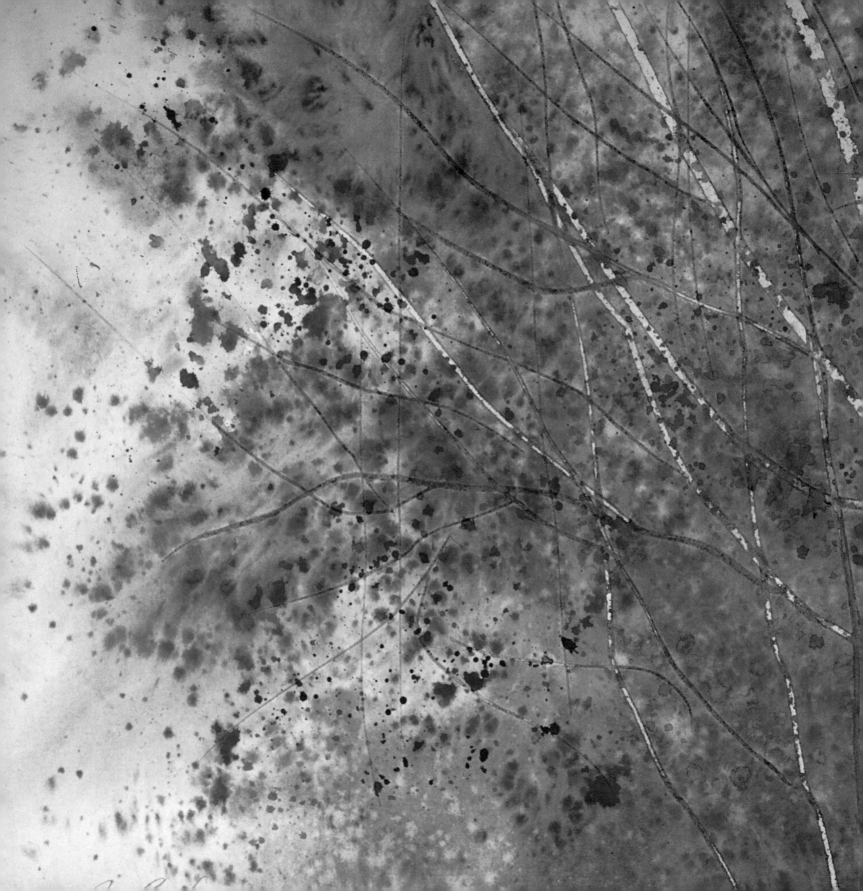

Centering

*Rather abide
at the center of your being,
for the more you leave it,
the less you learn.*

Tao-te Ching

AUTUMN TREES
13 × 16" (33 × 41 cm), 1985.
Collection of the artist.

*This painting is made up of
flat, full-body, and spatter
washes (see pages 25–26), with
spatter washes predominating.*

The Spirit of *Centering*

EXERCISE:

A Simple Ritual for Centering

Stand or sit with your paper and materials, ready to paint. Close your eyes and slowly imagine, however you can, your spirit self, your mind self, and your body self all coming together to be in this place, now. State for yourself, either aloud, in a whisper, or silently, your true purpose in this endeavor—to honor your whole self and the world by working from your heart.

In Tai Chi class, we begin our meditative exercise by "embracing the world." It is a simple gesture of extending our arms outward and around, drawing energy into our field. Then, as we move our arms slowly downward in front of us our knees begin to bend, and we sink our energy into our navel area. We have centered ourselves. We are prepared to begin.

In Sumi-e art, the painting master prepares in much the same way. As he slowly places his bowl of ink in the proper location and begins to grind his pigment, the deliberateness of his movement serves to close out everything extraneous. He becomes one with this activity alone, the act of painting. This meditative ritual focuses his attention, his spirit, bringing together the functions of mind and body. By leaving all else behind and concentrating fully on the present moment, he empowers his intention, which becomes very clear. Whether he's going to paint a bird or a flower, the Sumi-e artist wishes to create an emotional harmony of black ink and white space within the borders of a paper world. A trinity is established of man, nature, and the heaven he will point to with his brush.

That quality of spirit is called centering, a state I hope you will achieve with each painting session. I think it's crucial for you to be fully present with your private world as it unfolds, so that you're not caught off-guard by the challenging surprises that water and color can thrust upon you. Whenever you prepare to paint, I urge you to allow yourself some small centering ritual that will move you from the real space of practical existence to the symbolic space of the painter's world. If possible, create a sacred place in your home that is only for painting. Some artists are lucky enough to have a studio, but if you don't have space for one, try to appropriate a corner somewhere dedicated exclusively to your painting. In my home, my studio is at the other end of the front porch, near the entrance to the house. Though only eighteen feet away, my daily walk to my studio is a threshold crossing into that other world. Not even my mother will follow me there.

Whatever it takes for you, by centering yourself, your objective for the painting at hand will be much easier to see, and your chances of creating a successful painting will be greatly enhanced. At the very least, you will have given yourself a refreshment of practice and learning—for every painting is a path to self-knowledge.

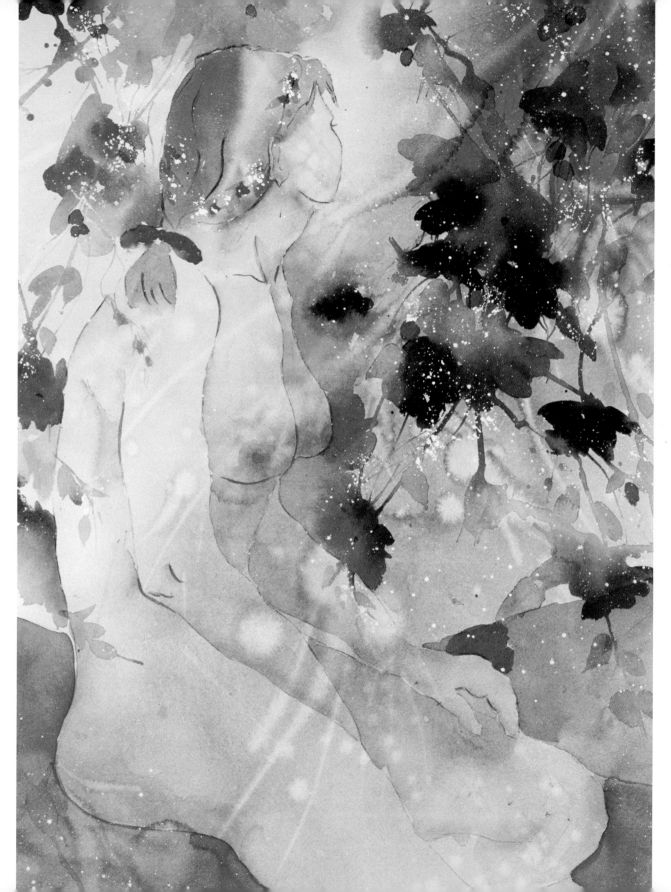

SEARCH FOR THE BELOVED
30 × 22" (76 × 56 cm), 1991. Private collection, Vermont.

The Mindfulness of Focus

*C*entering has a direct equivalent in the visual element of focus, which is the linchpin in the craft of picture-making. By concentrating on the concept of focus, your decisions will be made with focus fully in mind. Once focus is clear—not just the spirit of the work but also compositional centers of interest that draw the eye first—the painting itself tells you what's next, and it begins to paint itself. Without focus, the viewer is left to wander about the picture feeling unsatisfied, not sure where to go, where to rest the eye. Just as the writer's obligation is to tell readers who the major character is and what the central issue is, so it is the painter's job to tell viewers where to start and stop, to clarify what the story is really about.

The painting's theme, or central story, should be grasped all at once on first viewing. One can look at a Van Gogh landscape and know immediately that the theme is a "lust for life," a desire to have the viewer feel each blade of grass and flower along the way. When viewers see a landscape of mine, they know instantly that it's really about the transcendental nature of reality and the call to enter its mystery.

When focus guides the eye to a specific place to go in a painting—as in *Autumn Trees* (pages 18–19)—notice how the trees to the right of the opening point you to the opening itself. I think of this type focus as a mini travel picture. The viewer enters the painting at the subdominant trees, then moves to the focus of the opening. That relationship establishes the importance of the opening, which is rather elusive on its own. Were I not trying to take you to the middle distance of the opening, the trees would stand on their own as a focal point. But that would tell a different story and one not nearly as mysterious as I would like. Along those lines, I would mention that Van Gogh plotted big pictures where you might see two subdominant focal points before arriving at the main one. What a wonderful device to make viewers feel every nuance of his beloved earth.

The focus of a painting is on the greater mass, the lightest of lights, the darkest of darks, the brightest of brights, and the greatest amount of texture—but focus isn't necessarily on an object, per se. Whether the subject matter is realistic or abstract, the focus of a painting should say clearly to the viewer, "Here I am. Let me be your guide to this special story."

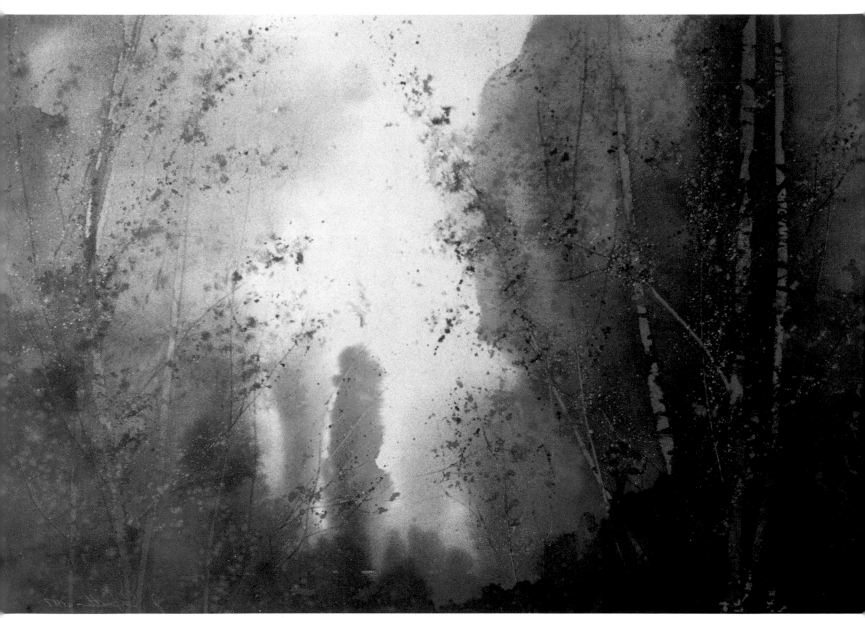

APRIL BIRCHES
22 × 30" (56 × 76 cm), 1988.
Private collection, New York.

The Technique of *Washes*

echnically speaking, a wash is usually half water to half pigment, the basic mixture that fills most spaces to begin a painting. A wash technique helps close in space, letting the viewer know what is and isn't important to notice. It quite literally brings a picture into focus by pulling forward a series of perspectives from faraway atmospheric conditions up to the close-up mass that holds the focus itself.

A series of developmental washes of different kinds can truly bring viewers into a watercolor painting and make them feel at home. On this page and opposite are a few of my favorite types of washes. Each can be laid on wet paper, damp paper, or dry paper, producing results ranging from no edges at all (full wet) to many edges (dry). A blending brush of clear water can soften desired edges and coax a graded wash along.

A flat wash *is a single, clear layer that fills in space. A wide brush, such as the mop brush used here, is usually best for application.*

A graded wash *is more atmospheric, moving from dark to light, creating an in/out effect. Lighter gradations are made by adding more water to the wash and softening the edges with a large round brush, such as a #12.*

A full-body wash *is made by putting more pigment than water on the brush, a good technique for layering such as in loose areas of foliage that need building up.*

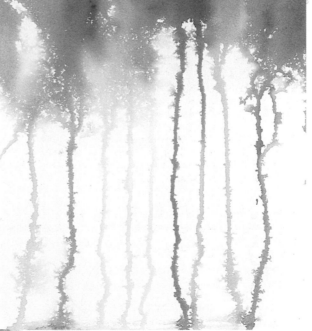

A drizzle wash *is similar to a spatter wash in that it creates atmospheric texture, produced by spraying the paper slightly, then adding paint to roll down into drizzles.*

A spatter wash *is a light wash consisting of dots of color. It's applied by tapping a brush loaded with color across a second implement, such a pencil or brush handle, causing the paint to spatter into dots. A light, atmospheric texture is produced, which suggests something appearing in the distance, such as foliage.*

25

Sometimes it seems to take forever to learn everything about the way watercolor behaves, especially when working with washes. Please don't be discouraged. I assure you that the more often you paint, the sooner you'll handle washes with ease and come to know the following things that I've learned about their special nature:

- Paper is our trusted partner when producing washes, so I avoid using "practice paper" (Robert Frost once said, "You don't write a practice poem"). To use another paper is like playing soccer in the hopes of getting better at basketball. My preference is Arches 140-lb. cold-pressed paper (see "The Tao of Tools" chapter for other suggestions).

- Whichever paper you choose, get to know it well. Allow your paper to speak to you. It will tell you when it's ready to fulfill your desire.

- *Full-wet paper* is covered with water, but not made so wet that it forms puddles or runs when tilted. Color should move when it hits the water, but not "explode" (unless you want it to). Full-wet paper is perfect for graded and flat washes that give atmosphere and beginning substance to a painting—but note that it's always a bit wetter than you think it is, so watch for forms that may travel even when you think they've stopped.

- After the first wash layer has dried, I always wet the surface again, using a sprayer. This keeps colors from lifting too much. When the fibers of the paper sit up, they're saying, "I have enough color and water now; please let me rest." Then it's important to let color "sink in" before going on.

- *Semi-wet paper* results from making patches of the paper wet and leaving others dry, allowing for both blended and sharp edges. This is perfect for various impressionistic techniques, where you reserve dry areas for painting the sharp edges of realistic forms, and wet areas for soft, blurred, atmospheric effects.

- *Damp paper* differs from wet paper in that it has no shine. You'll get a clean circle if you touch the pad of your finger to it, which means it's just right for drawing with water, scraping out, or spattering (discussed in detail later). Damp paper isn't usually good for receiving color, as the color will tend to sit in a clump. (The time for adding color is a few moments before you can make a fingerprint; then the first color has had time to sink in, but is still wet enough to integrate new color.)

- *Dry paper* is suitable for all forms and textures. Just make sure of the edges you place; once an edge, always an edge.

- Every technique can be used on any type of paper from very wet to very dry. The possibilities are endless. Experiment and develop your own strategies. It's just a matter of timing, but timing in watercolor, as in life, is everything.

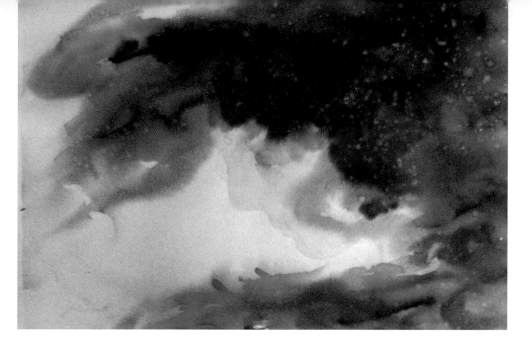

PSYCHE
22 × 30" (56 × 76 cm), 1989.
Collection of Dr. Maureen Bunce.

- Brushes should always be plump with water and color—not be dripping nor too flat. You can tell when a brush hits the paper: There should be a soft landing, and color should sit up for a moment before sinking. This gives you time to make any adjustments you need. If the brush skims your paper and leaves gaps, you have a "dry brush," a good technique for final texturing details, but not usually suitable for first washes.
- Avoid "pawing" the paper with your brush. A light skimming lays in color and allows it to swim, without forcing it into the paper fibers. Pawing with subsequent washes can lead to big trouble. More than any other problem, I believe that is the way the dreaded "muddy" watercolor painting is created.
- When it comes to brushstrokes, avoid making more than two in the same direction. (Think of it as employing the "Arthur Murray" rule to painting. Back in the 1950s, when he taught ballroom dancing on television, it was always, "One, two, change direction.")
- If a wash looks too anemic, mix more pigment than the usual ratio (half and half) to water. Color looks at least 20 percent lighter when dry as opposed to wet, so what might appear garish wet may be quite tame dry.
- Spatter washes and drizzle washes look easy, but they require great timing. Allow me to say again, in watercolor as in life, timing is everything. Watch your paper closely (as a mama watches her baby) to make sure spatter doesn't move too fast and lose itself or stay too dry and sit up too much on the paper. For drizzle washes, avoid letting your paper be too wet. It should be just damp, with dots of water still visible from the sprayer. You can direct the flow of your drizzle wash by aiming the sprayer at the bottom of the drizzle.
- Finally, a very important thing I've learned about washes is always to back up often to see the big picture, to make sure that the whole is working, not just the parts.

Demonstration: # The Atmospheric Landscape

STEP 1. *Here, I work on Arches 140-lb. cold-pressed paper, using a one-inch mop brush to lay in my flat and graded washes of turquoise and phthalo yellow. I roll the paper from side to side and up and down to allow the colors to mix a bit.*

o whatever is appropriate to center yourself in preparation for working on a landscape painting, using the example that follows for guidance. Once you've determined where your focus is, the painting itself will speak up, advising you how to proceed. As you work, remember to back up to see implied directional lines that are lost in close-up viewing.

Ask yourself, "Is my focus clear?" If it is, wonderful. If not, that's all right, too. Perhaps you just need a bit more paint, or one stronger tree trunk in your focal area. Usually when students say, "This isn't good," they're simply judging the painting too soon, jumping ahead of the present moment.

STEP 2. *After the initial washes dry, I wet the paper again with a sprayer and apply a full-body wash of phthalo green and phthalo blue. I'm careful to leave some dry patches next to the color I lay down. This gives the painting a few distinct, dry edges that will make it easy to integrate the forms of trunks and branches to come.*

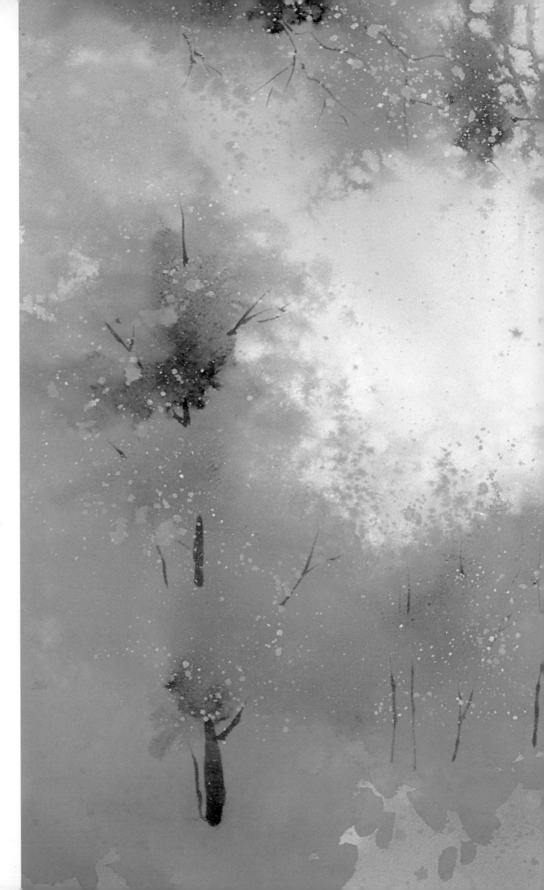

SUMMER GREENS
22 × 30" (56 × 76 cm), 1997.
Collection of the artist.

I'm careful to lose and find the trunks and branches as I add them on dry paper, using a #10 round and a #5 rigger brush. Now the full-body washes come to life as they suddenly transform themselves into quite realistic trees and foliage. A spatter wash gives a soft and lovely atmospheric texture to light areas.

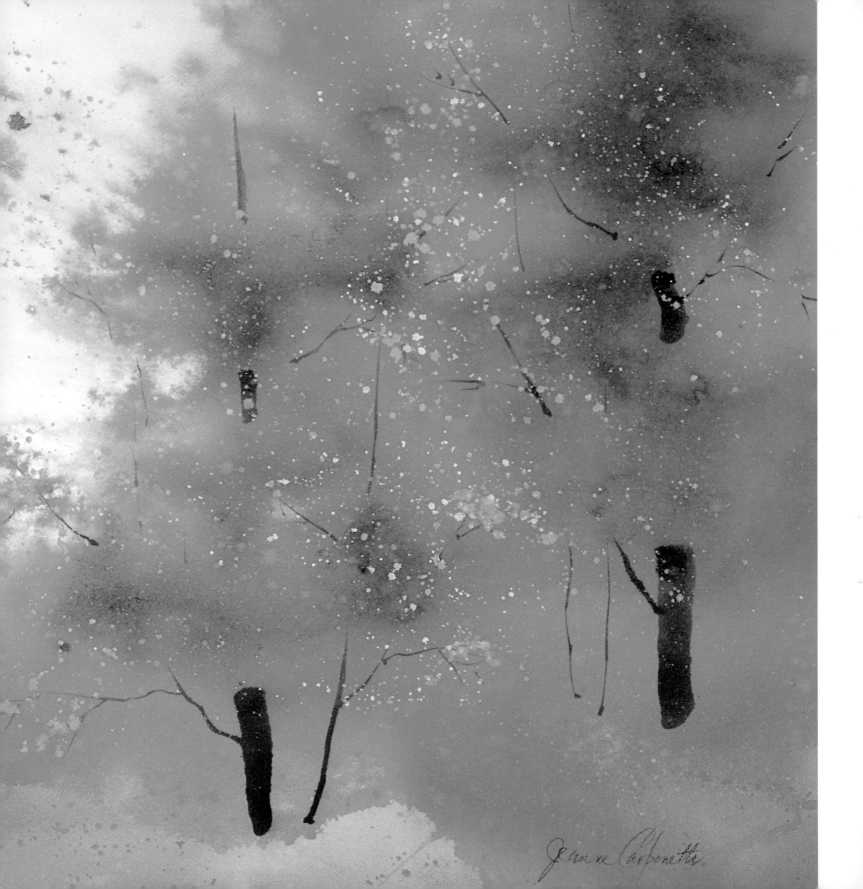

Jeanne Carbonetti

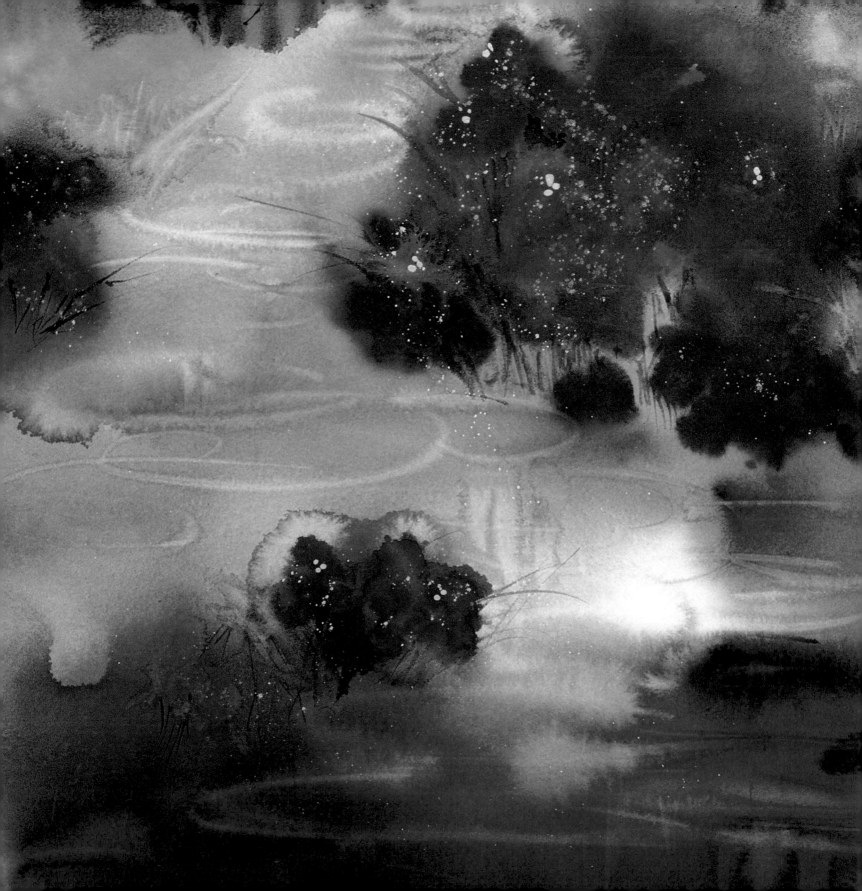

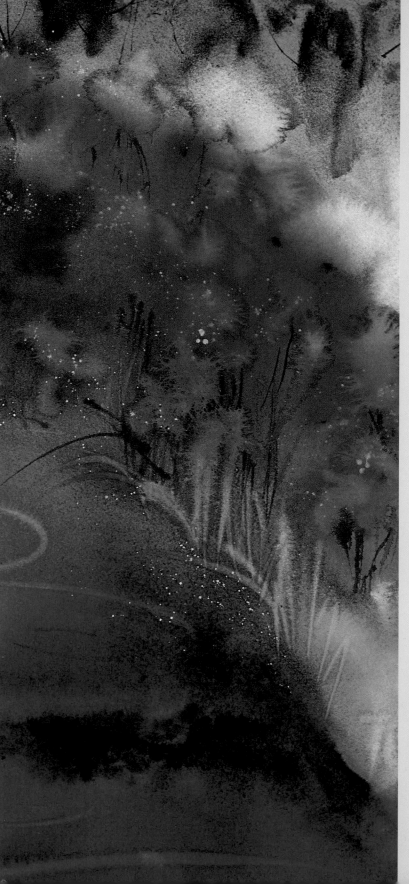

Balance

The Universe,

like a bellows,

is always emptying,

always full.

The more it yields,

the more it holds.

Tao-te Ching

RIVER IRIS
22 × 30" (56 × 76 cm), 1996.
Collection of the artist.

*The concept of blocking is crucial to the
"ruffling" technique (detailed later)
used here. It allows for maximum
movement to occur while still making
sense of the overall story.*

The Spirit of Balance

EXERCISE:

A Simple Visualization for Balance

Close your eyes for a moment. Feel and hear your own breath. Now you are centered within yourself. Imagine yourself painting at a lovely, rhythmic pace, not too fast or slow, but smoothly, responding to all parts of your painting, yet mindful of the whole. Speak in your own way to your intention, to allow all parts of the painting to give their perfect gift to the whole.

A memorable scene in the film *Karate Kid* shows the young boy practicing a stance, standing on one foot on a tree stump. It becomes a metaphor for the whole film, for the discipline of keeping his balance, no matter what happens, ultimately helps the boy keep open his responses to his bully opponent, which results in his winning the match and the day.

In Tai Chi class, we do a lot of standing on one foot, too. We learn early that for every yin, or receptive move, there is a yang, or thrusting move. Always there is the flow between two poles, one leading to the other endlessly. That is the principle of balance. It is a dynamic balance. *Dynamic* balance has nothing to do with rigidity or inflexibility. Rather, it's the ability to respond immediately, to go in a completely different direction instantly—the mark of a Tai Chi master. Like a great panther, the Tai Chi player is always in neutral, but always aware of everything, able to move anywhere.

In much the same way, the art of Sumi-e is a matter of dynamic balance: creating paintings made completely of black ink, but often giving an impression of having color through the skillful manipulation of tone. In traditional Japanese schools of Sumi-e, one would learn the art of white space by making single marks of black ink. Every stroke thus changed completely the balance of black and painted space.

For example, in one of my favorite motifs from *The Mustard Seed Garden Manual of Painting*, bamboo and falling leaf are on a squarish piece of paper. A single bamboo stands on the left side and leans slightly to the right, leading you to the falling leaf. The leaf shape is "back there," while the bamboo sits up front, and great depth of space is implied between them— all in blank space! This is what is known as *wu-wei,* the fullness of the empty, achieved through the principle of balance.

As for the spirit that one brings to the practice of painting, it is the ability to respond with a fresh outlook to the dynamics of brush, water, and paper. It is not to force anything, but to *respond* to everything—without getting caught up in details too soon, which can be a fatal mistake in painting. (Rembrandt said that we should *view* a painting, not "nose" it.) See *all* the space, not just painted space, as being worthy of your attention—and when you think of empty space as being full of potential—that just may be the secret to success in painting as it is in life.

RED GLADS
30 × 22" (76 × 56 cm), 1996.
Private collection, Bahamas.

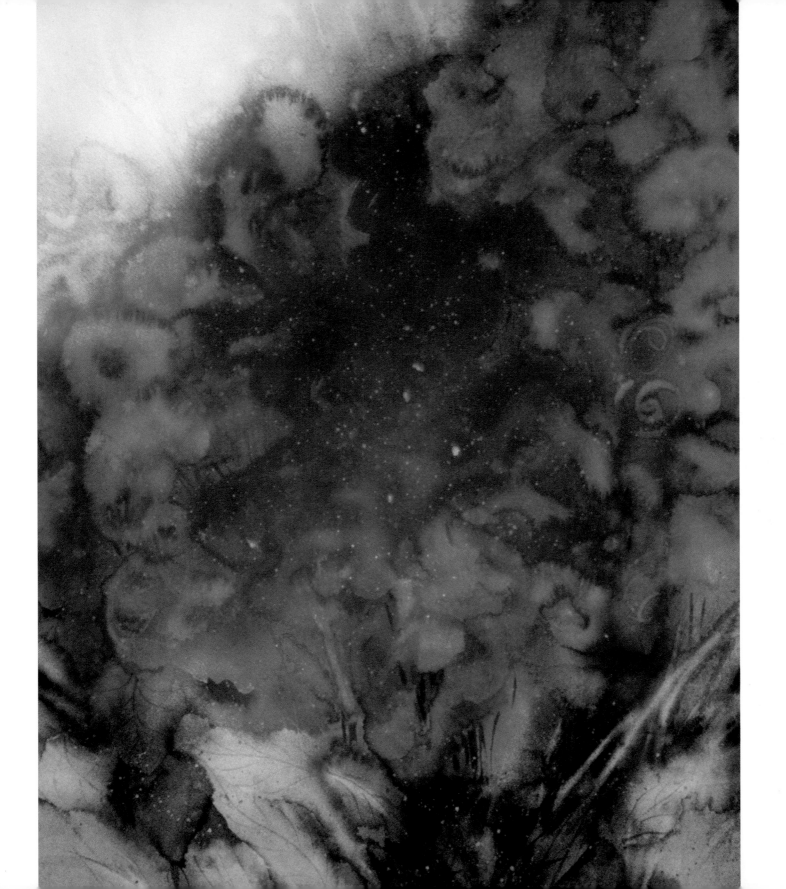

The Mindfulness of Composition

This diagram of my blocking of Meditation Forest *shows how I simplified the picture into its big component parts. That's the essence of composition: seeing the big parts of the big picture.*

In the craft of picture-making, the spirit of balance is best exemplified by the concept of composition, the arrangement of elements in the space within the borders of your paper. Like the Oriental master, the painter sees all space as full space. Every mark changes everything. One must learn to be mindful of the whole picture, all of the time, when composing a painting.

If I were limited to giving my students a single lesson only—one that more than any other would make them better painters—it would be this lesson about composition. It is composition that makes or breaks a painting. While a watercolor may have an absolutely gorgeous tree in it, if that tree is in the wrong place, if it guides the eye away from the focus instead of toward it, the painting will suffer. A painting must work abstractly before it can work realistically.

How do you find the best composition for all the elements you want to include in a painting? You begin each painting by blocking. It's interesting to note that not only painters use this term and concept; other artists do as well.

One day I visited a theater-director friend while she was "blocking" her characters for a play. Before they ever began learning lines or building characterizations, they were arranged onstage in relationship to one another for every scene. I was delighted to witness it. Here was composition in action, carried out at the same early stage as blocking is undertaken for a painting.

I'm sure that blocking is what Paul Gauguin meant when he referred to being "plastic" with painting shapes. Think of your painting in those terms, as a big jigsaw puzzle, then block in all your major shapes. If it looks right, chances are good that your painting will work. Now, please notice that I said *major* shapes, that is, big, broad, simple lines to define the largest elements of a composition. Once those are taken care of, the little pieces will fall right into place.

MEDITATION FOREST
25 × 24" (64 × 61 cm), 1997.
Collection of the artist.

Crucial to the blocking of this painting were the two rose, oval shapes that created a junction where they joined the yellow. This easily designated the area of focus, adding more interest to a very simple painting.

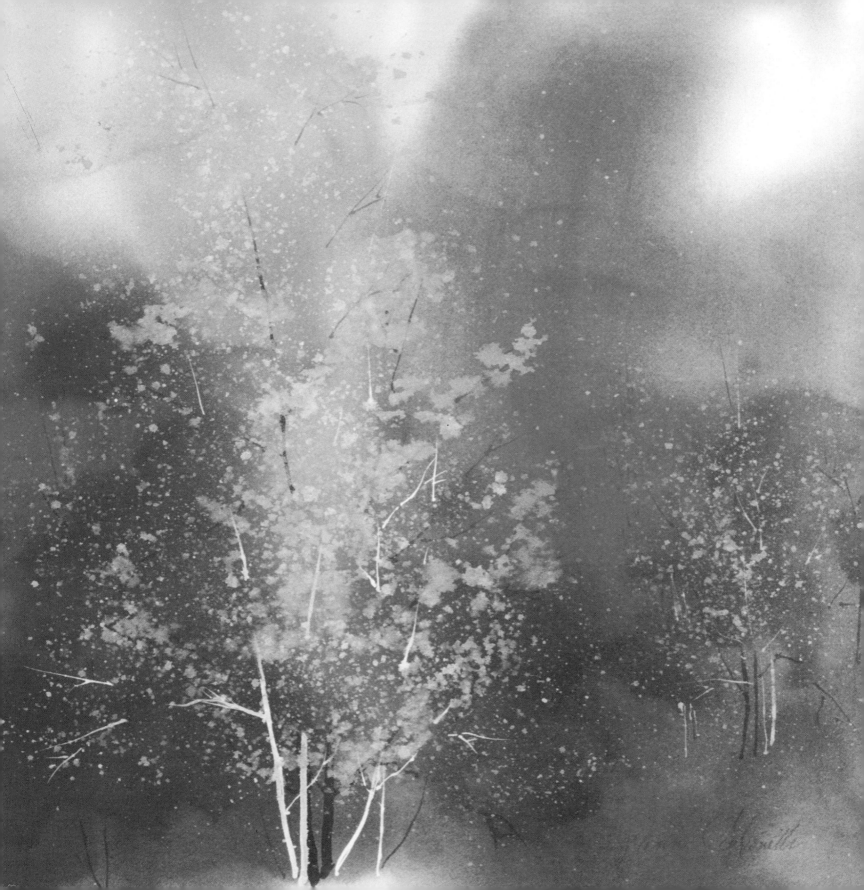

The Technique of "Ruffling"

One of the best ways to show off good composition and emphasize balance is to use a technique I call "ruffling." Sometimes it's known as "bloom," and is classically referred to as "drawing with water." (I've also heard the process labeled "wash back," a dreaded effect, depending on your perspective.) I take the technique a step further than it's normally applied and use it to create the major textures for the body of a painting.

Because it is so dependent on a strong arrangement of shapes in proper balance, the energy that ruffling creates will only make sense if the composition is very clear and profound. The simpler the blocking of the painting into a jigsaw puzzle of shapes, the easier it will be for the painting to speak to the viewer. While this is the case with all kinds of paintings, it is especially true of ruffling.

When I use the technique, I literally paint my subject with water into damp color already blocked on my paper, producing the wonderful effects that you see in *River Iris* (pages 32–33) and other examples on the next few pages. Somewhat different from washes, which lend themselves particularly well to the atmospheric conditions of landscapes, ruffling lends itself to the making of luxurious flowers, still lifes, and gardens. When played up in a painting, the technique imparts powerful energy to a piece. Used sparingly, it gives just that spark of life that a quiet still life might need. I'm particularly fond of the effects produced because it's the combination of paint and water rather than drawing that evokes the feel of the body of a flower or clump of blossoms. This keeps the flow from being slowed down by lines and edges. The flowers look like they're growing right in front of you.

STILL LIFE WITH PEONY
22 × 30" (56 × 76 cm), 1994.
Collection of the artist.

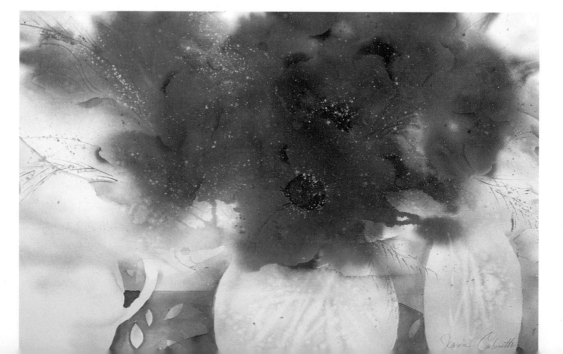

Blocking a simple jigsaw of shapes gives me a composition that has good balance and interesting divisions of space.

Applying colors to wet paper, I make no attempt to "stay in the lines." Instead, I let the paint do its own miraculous work at establishing the essence of my picture. The colors I use here are mauve, scarlet lake, turquoise, emerald green, and a dash of phthalo green.

For my "ruffling" technique, working on color that's still damp (determined by the "fingertip" test discussed earlier), I add flowers and leaves, painting with water instead of pigment.

A Bit of Annie's Garden
14 × 10" (36 × 26 cm), 1997.
Collection of the artist.

Using two brushes—#5 and #10 rounds—I pull out edges by painting a shadow around curved areas to give the flowers a sense of form without having to do too much shading. I pick out just enough edges to pull my focus forward, integrating the fluid parts with the drawn, dry parts. If I pull out too many edges, I'll have a cutout look and no fluidity.

Things I've Learned About *"Ruffling"*

It's worth repeating: There is nothing like painting with water to teach you mindfulness. Here are a number of important points about this fascinating technique to keep in mind:

- Be aware of all parts of the painting at once, for each part will dry at a different speed; outside edges usually dry first. Timing is everything. Rely on the fingerprint test. The paint is too wet if you lose the fingerprint and too dry if you can't get one. When your fingerprint shows up and stays, it's the right time for painting with water.

- When blocking in color (as the earlier step to ruffling), use enough pigment for the water to have something to penetrate and show up against. Too little color will keep the ruffles anemic. Use a plump brush, full of pigment.

- Make value adjustments, such as adding darker color, while the painting is still wet. This helps avoid working the paper too much later on, which would hinder the main gift of painting with water—movement.

- Allow yourself plenty of time to listen to the painting tell you how the shapes are turning after ruffling. Even though you painted an iris in one direction, it might now be looking in another. Balance is about responding to what truly is at hand, not forcing. The *Tao-te Ching* says that perfect balancing is "of a man at endless ease with everything."

- When doing the final detail work, don't go too far. Every edge will decrease the flow. You want to integrate form and fluidity.

JAPANESE PEONIES
30 × 22" (76 × 56 cm), 1996.
Collection of the artist.

Bold Garden Landscape

ake a moment to breathe deeply and imagine yourself and your painting beautifully balanced. Start with a landscape or image of flowers in your mind. For this exercise, don't worry about an actual scene. Instead, go for the essence of a garden, as in the ruffling demonstration that follows. That way, you'll feel freer to let the process of painting with water take over and work its exceptional effects.

STEP 2. *I wet my paper well, using a sponge brush. Filling in strong color, I work with a mop brush, by beginning with turquoise and emerald green. Then I add phthalo crimson and mauve, always patting the paint, rather than rubbing it in.*

STEP 1. *On Arches 140-lb. cold-pressed paper, I block in simple shapes with broad lines, creating a jigsaw puzzle that feels good in the space. By limiting my blocking to only a few large shapes, I avoid the trap of introducing details too early in the picture. The blocking tells me right away that the spaces "read" well—none are too small or too large, and there is already a sense of where the general area of focus will be.*

STEP 3. *While the paper is still damp, I paint the flowers and grasses with water. Once dry, I pull out the edges of flowers so they exhibit just enough of their characteristic shapes. What I'm actually doing is painting a shadow around a shape, being careful not to go too far and risk losing the beauty of the flow.*

ANNIE'S GARDEN
26 × 22" (66 × 56 cm),
1996. Collection
of the artist.

Deliberateness

Let life ripen and then fall;

force is not the way at all.

Tao-te Ching

Japanese Lilies
25 × 27" (64 × 69 cm), 1995.
Collection of Charles
and Carol Cox.

The Spirit of Deliberateness

EXERCISE:

A Simple Path to Deliberateness

The best way to do is to be. The surest way to make your brushstroke clear, strong, and essential is to wait for a moment and breathe deeply. Step back and look at your painting as a whole. Then wait for your tummy to jump. When it jumps, it's a "yes" and you feel it. You know the brushstroke goes there, not here. Now you can be deliberate.

Have you ever watched a young child paint a picture? It's a perfect example of deliberateness. The child just paints a boat, a person, or any subject matter, with no backtracking, no judgment, and no hesitation. For children, there is no separation between their intention to draw a boat and the marks they make to represent it.

Deliberateness is probably the most difficult lesson for an adult to learn, not because there's anything mysterious about it, but because it's so subtle, and the most subtle concepts are often the most powerful. To gain a spirit of deliberateness, our grown-up selves must relearn what we knew instinctively as children: There is no separation or fear between "I want to do this" and "I will do this." It is the purest kind of concentration, requiring the greatest trust. In painting, as in other pursuits, it demands an absence of judgment at important stages of the process. This approach is natural for children, but for adult artists who have learned to judge their every mark and continually fear that those marks aren't good enough, the lack of deliberateness impedes the creative process.

To overcome that problem, in Sumi-e schools of painting, the student simply stands poised before his paper and waits until he feels where the first mark should go. This easy and deliberate stroke comes from the whole body, not just from the head or hand. Subtle? Yes. Why? Because the difficult part is the waiting and feeling, not the painting. While Sumi-e students are attuned to waiting and feeling, Westerners are usually trained or encouraged to do, to act. Emphasis is placed in our culture on producing, on not "wasting time." Yet, Leonardo da Vinci, who had one of the most inventive minds and genius talents in the annals of Western culture, said, "It is when I seem to be doing the least that I am really doing the most." Doing and producing certainly have their place, but there are times in the painting process when we should wait and feel, letting our yin, or receptive nature, rather than our yang, or assertive nature, take over.

In the physical movement of Tai Chi, this same principle applies. The player waits until power is gathered in the *tan tien,* or center of the body, never just from the arms or legs. In partnered teams, one player waits for the other to move, never moving in one direction too soon and giving an opponent the edge. Then, when the moment to move comes, which is the subtle feeling that one's opponent is off his central point of balance, like a wave of water, power comes up from the feet and legs, and the loose arms unleash all that force without effort themselves. Just like fruit falling from the tree—when the timing is right, the fruit falls.

And how does one get that sense of timing? By pausing long enough to let the feeling guide you. That is all. Some would say that something so easy is what makes it so hard. It takes a lot of patience to just wait.

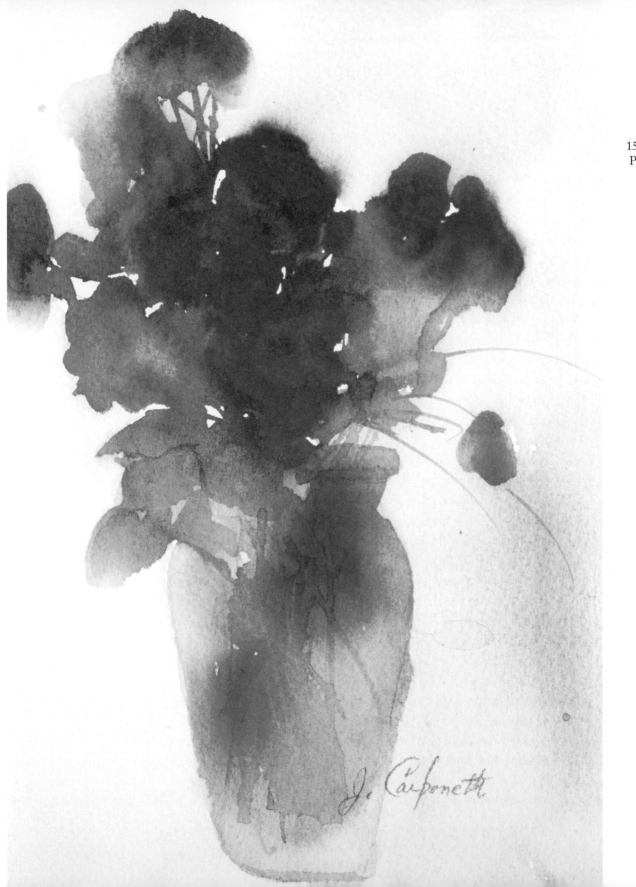

EMILY'S FLOWER
15 × 10" (38 × 25 cm), 1997.
Private collection, Vermont.

The Mindfulness of *Values*

All medium values can render a painting lifeless.

A light-to-dark value range enlivens a painting.

he visual concept of values is the classic equivalent in mindfulness to the spirit of deliberateness. After focus and composition, the painter wants to keep in mind the use of values—that is, the range of lights and darks throughout a painting. I have often said that my dying words to my students would be, "Back up!" (to see the big picture) and "Go darker!" (for contrast). A variety of values from light to dark gives body, weight, and life to a picture. Much too often a painting turns out only OK and not great because the student decided to play it safe and not take chances. But without that deliberate dollop of dark value that sings to the viewer, "Notice me," there is safety in the expression, but no real life.

What Mother Nature does with atmosphere, an artist does with values. We use values to give dimension to an object, to describe its roundness, curves, or depth. Values can take you into a scene, bring you out, or guide you around. But the most essential aspect of values is that they need to be in a range of contrasts that allows their story to be told.

Just how do you know where a value change is needed in a painting? Think of a space about the size of the palm of your hand. As a general rule, only that much space can be all the same value, without any change. Bigger than that and you usually have a hole in the painting that sucks in all the energy around it, even though it seems to be nothing in itself. Medium values are, of course, what most of the painting will be, but broken up by other values on the scale. The lightest lights and darkest darks will always draw the eye to the focus, but what do you do with all those medium values that can't be too dark or be allowed to float by being too light?

The answer is to be deliberate. When you step back and pause for a moment and your gut goes right to that lower left corner where the same color and value predominate, go for it! If your attention draws away from focus instead of toward it, throw in some darks, the way a spider would anchor his web at the corners. It doesn't need to be a big anchor; just a dark one (or a light one), something a little different from the rest.

As a final note, I would like to emphasize the notion of values as weight. Some paintings are called lower-key, due to a predominance of deeper values. Higher-key paintings are lighter in weight because light values are dominant. Either is correct, according to its appropriateness to the theme of the work. However, all parts of a painting need to have a certain unity of weight so that the parts fit together as a whole. For example, a still life of bold, brightly colored flowers with deep values will look top-heavy if the vase is painted in a very light value range. This is what Picasso meant when he said, "You have to tell a lie in art in order to tell the truth." Even though in real life dark flowers may look fine in a light vase, your painting will call for a closer range of values, so you'll need to manipulate them a bit by throwing in a touch of deeper value to translate clinical reality into the metaphoric reality of your painting.

The Technique of Blended Wet

In the technique of blended wet, deliberateness is applied in two very specific ways: in the brushstroke of paint itself, and in the use of values. Blended-wet watercolor technique means working primarily on dry paper and only wetting small portions at a time. Therefore, you'll have very specific kinds of brushstrokes to deal with. The challenge is that you must constantly decide whether you want an edge or not. Because it incorporates forms with fluidity, blended wet is a technique that appeals to abstract and figurative painters alike. As in painting with water, working with blended wet will certainly keep you alert; you won't want to be conversing while having to make quick creative decisions.

Observe the differences between blended-wet technique at the starting point versus working on completely wet or completely dry paper, as shown in the three examples on this page.

Completely wet.

Blended wet.

Completely dry.

A flower painted in water will produce a lighter value, a lighter version of flowers, so to speak. That aura will make the flowers look more realistic later on. Here is the paradox (one of many in painting), and I believe the great secret to this technique: To have your subject appear more lifelike at a later stage, you must allow the forms to spill into each other first. The key is to be carefree about it. You may have painted a flower looking toward you, then when it dries, because of overlapping, it seems to have its back to you. That's just fine. You, the water, and the color are working together.

As the painting evolves, overlapping provides the spill that gives the real-life look of density and atmosphere. This is how painting, as opposed to drawing, creates reality. In painting, it is modulation of values that is primary in developing the body of a form. In drawing, it is line that does so.

When I begin flowers in blended-wet technique, I place a brushstroke of water on the paper, then apply color along the edge of the stroke and let it spread. That's all the water I use for the moment.

Here, I overlap a flower painted with color with one painted only with water, repeating that procedure a few times to fill out the bouquet, alternating painting with color and painting with water. Overlapping allows some of the form and color of one flower to spill into another. Successful blended-wet technique is based on overlapping, integrating, and always working from a wet edge.

Working from a wet edge will always allow you enough time to choose which edges should be dry, which wet. Here is where deliberate brushstrokes are important—and by that I mean that the *brushstroke itself* is pleasing and harmonious. It doesn't matter at this stage if a certain flower is painted in a particular direction. In other words, you need only care about putting nice "blobs" in appropriate places; they don't need to be discernable objects just yet.

Stepping back often to see if an edge fits in or doesn't will tell you how to proceed. Generally speaking, forms seem to be more blurred and massed at the center, with more specific edges at the perimeter, just the way we would tend to view them.

When my general color blocking is complete and the paint is still damp, I drop stronger, darker, and brighter paint into my focus area and other accent points in the painting. Again, it's important to be deliberate. Risk mistakes and you'll probably add life to your work.

Observe the deliberate edges here. I made careful choices, deciding which edges to leave dry and which to let spread. Reminder: It always helps to back up for a long view in making such decisions.

These are obviously tentative, ragged edges. Decisions weren't made by stepping back in this case. Although there is some life in this spill, it would be difficult to bring it to a realistic form without losing its free flow.

The principle of integration is very important at this point. Try to integrate edges with the fluid portions of your painting to achieve a balance between the two. Too much fluid and no form makes a painting look unfinished; too much form with too little fluid makes it look overdone and you may end up with more of a drawing than a painting. For a good, final, integrated look, understatement brings out the best in blended-wet technique.

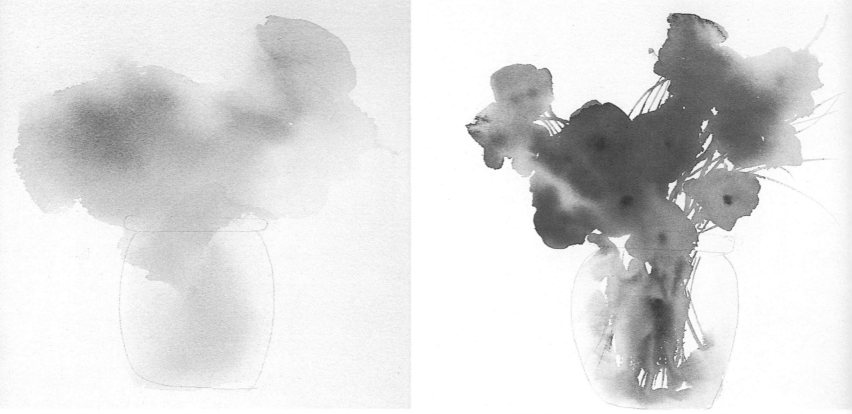

All medium values and tentative edges produce little of the animation that results as soon as value contrast and deliberate edges are introduced, as in the example to the right.

Notice how much life this painting has, even at this unfinished stage. All that's needed now is a bit of contour painting to pull out some important edges on selected forms.

Blended-Wet Technique

Always work from a wet edge. This gives you the time to make decisions before you have too many dry edges, and it also allows for some spill to occur in each form. Other important aspects of blended-wet technique that I'd like to share with you are these:

- It's critical when beginning a painting to avoid worrying about describing flowers or other forms specifically. If you belabor them, they'll have too many edges, and then your work will read as if it's in one plane only, instead of appearing three-dimensional.
- Edges should be pleasing to the eye and have a nice shape, whether or not objects are identifiable. For the beginning stages of a painting, I think it's best not to know what the forms are.
- Apply two brushstrokes, then back up and survey the scene before making your next decision.
- While your paint is still damp enough to show your fingerprint, place some thicker, more full-bodied color in your focal area for value range and textural variety.
- As final steps: Be mindful of contour painting, noting that curves say more with less edge. Allow for the integration of the fluid and the formed by not going too far.

This unclean blended edge results from too much color having been pulled out by perpendicular strokes of water.

The clean blended edge in this example has been "tickeled" by brushstrokes of water parallel to the color.

Demonstration: Limited-Palette Still Life

Painting a watercolor restricted to three colors will really reinforce your understanding of values. In this demonstration, we use yellow, blue, and red only, enabling us to work with a value range of all three important primary colors. Yellow, for example, will always be a light value, no matter how dark you try to make it. Blue will always act as at least a medium value. Red will always behave with the power of a dark value.

Use thumbnail value sketches whenever you have a question about how to manipulate a value range. They are quick to do, provide you with great information, and are useful for blocking, too. To create a thumbnail value sketch, make a small box, no bigger than your hand, in the shape of your desired painting. Block in very simple, broad lines, and fill in with the appropriate values of light, medium, and dark. Does it feel right? If so, your final painting should be successful.

STEP 1. *On wet, 140-lb. cold-pressed paper, using a one-inch mop brush, I pat on turquoise in the upper-left quadrant, lemon yellow in the lower-right quadrant, and place quinacridone rose on a diagonal from upper right to lower left, letting the colors flow into one another. I make the lighter splotches by spattering water onto the paper when it is "fingerprint damp," which means the paper is half dried. (I spatter by tapping my #10 round brush loaded with water against a pencil.)*

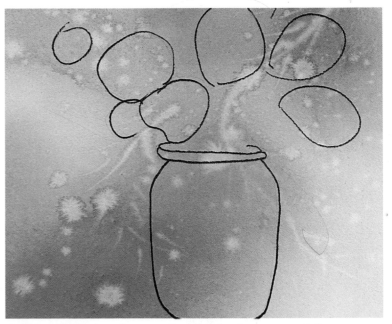

STEP 2. *I've darkened my pencil outline for the purposes of this demonstration's block-in; normally, it's best to sketch very lightly when blocking for watercolor. This blocking is done after the initial washes have dried completely. While the blocking of my vase is realistically drawn, I'm not too specific where the flowers are concerned, giving them somewhat abstract shapes so that I won't be tempted to "stay in the lines."*

56

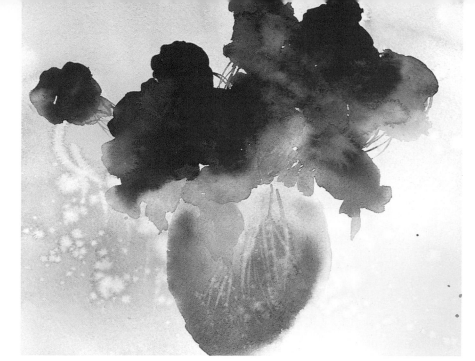

STEP 3. *Now I mass in loose shapes, being concerned mostly with* where *the blobs are, not* what *they are. To get a deeper value, I add stronger color while the paint is still damp. Note how the mingling of yellow and blue imparts appealing touches of green.*

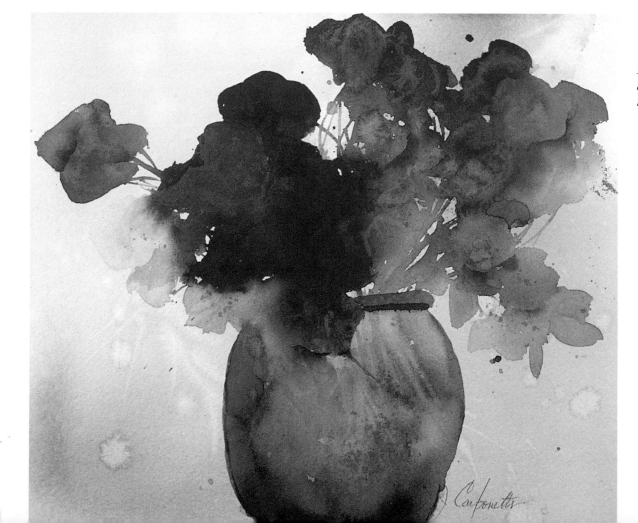

JAR OF ANEMONES
12 × 14" (31 × 36 cm), 1996.
Collection of the artist.

I pull out needed edges and adjust values, muting background tones as well.

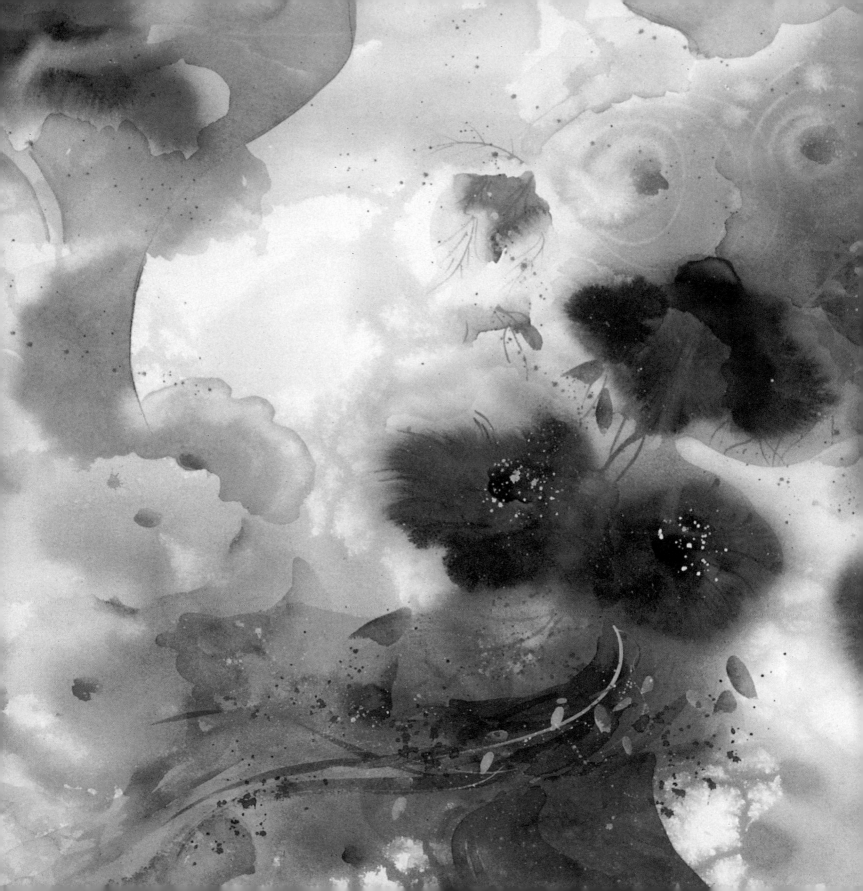

Playfulness

He whom life fulfills is as

though he remains a child.

He doesn't think about

his actions. They flow from

the core of his being.

Tao-te Ching

PLAYFUL PITCHERS
20 × 30" (51 × 76 cm), 1995.
Collection of the artist.

The Spirit of Playfulness

EXERCISE:

A Simple Visualization for Playfulness

Stop whenever you hear the inner voice of criticism. Close your eyes for a moment and feel your breath. Imagine yourself as a child, standing in front of you, helping you make the painting. If there were a real child there, you would be kind, wouldn't you? Well, there is.

I take play very seriously. My awareness of how important the spirit of playfulness is came over many years. When I was new to the watercolor medium, I would begin, do my thing, then the paint would do its thing—and if it turned out all right, it was really due to the accidental effects of the medium, not because of me. At that time, the medium was master.

Years later, as I developed a better grasp of techniques and didn't have to think so much about each one, my participation in the painting experience became very forceful. I would decide ahead of time just what I wanted a certain painting to look like, then proceed until it turned out exactly that way. It was hard work because I was expending lots of crafting energy. But, oddly, I was seldom satisfied, even though I had accomplished my goal. It was only much later that I understood why.

It began to dawn on me as I entered a third stage of working with the medium that watercolor and I were partners, dancing together. I would lead by beginning the painting—a still life or a scene—but soon the paint, paper, and water would have their say and give me something excitingly unexpected. Now it was up to me to use what I had been given, to explore and celebrate it, rather than deny it. This transforming experience brought new life to my work. A vibrancy and power began to supplant the tedium of safe painting. I was practiced enough at that point to respond in any number of ways, rather than just plow ahead on a forced course. I had become playful.

To me, playfulness is not the same as playing. I view the latter as being an open-ended experiment, just to see what happens, where I see playfulness as a more directed, responsive experiment. Playing is like aiming an arrow into free air. Playfulness is like shooting at a moving target. Playing has its very important gift to give. But it is playfulness that concerns me here, the spirit that captures the opposite poles of experimenting and forcing, and forms them into an alchemical synthesis, making the experience both mystical and practical, guiding the painting to be not just successful but visionary.

The great poet Robert Frost talks of work and play in "Two Tramps in Mud Time," telling us, "where work is play for mortal stakes, is the deed ever done for Heaven and the future's sakes."

And in Tai Chi discussions of work/play it is said, "I begin after my opponent, but I am there before him." This means to the player of Tai Chi that one must be completely neutral as one waits for the next move to come, ready to spring into action in any direction. If one "jumps the gun," one is already off balance, and the ability to respond is lost. This concept is equally apparent in the art of Sumi-e, for in every moment the painter is simply responding to the mark made.

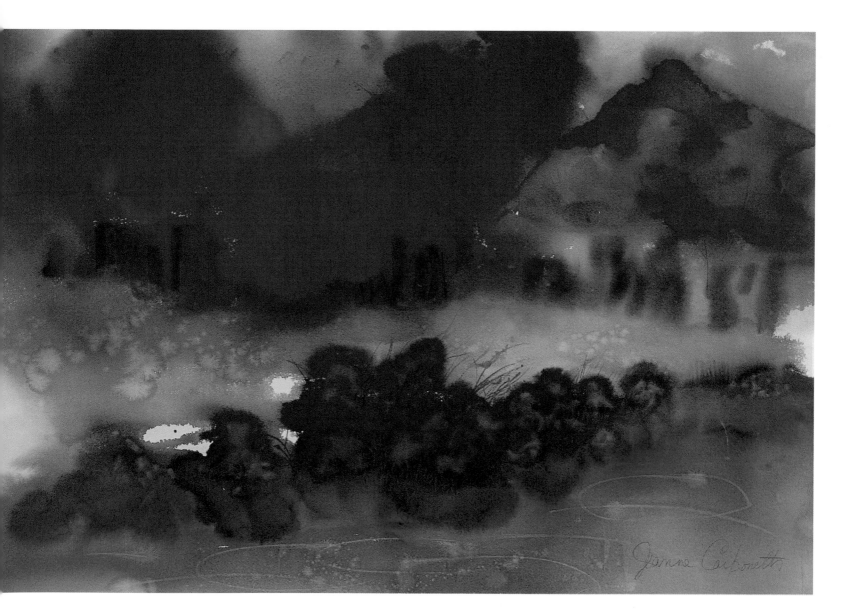

ADVENTURE IN TUSCANY
22 × 30" (56 × 76 cm), 1997.
Collection of the artist.

This may seem to be a paradox, since both the Tai Chi and Sumi-e schools have explicit modes of procedure, but both are premised on learning what you can do so deeply that you develop automatic responses. Thus one is free to expand in any number of ways. Playfulness, then, is the ability to respond with the newness of a child's wonder and the skills of a practiced adult.

The Mindfulness of *Color*

The visual principle of color is the epitome of playfulness, because color responds to its environment in varied and synergistic ways, always affected by whatever it's near. Then there are the effects of color upon viewers, which can be quite strong and go quite deep. There is also technical information about color that is learned gradually through working experience. But, above all, there are some broad concepts about color that are good to learn up front and to keep in mind.

Color Temperature

The temperature of a color is either warm or cool. Considered warm are reds, oranges, and yellows; cool colors are greens, blues, and purples. However, hues can have a warm side and a cool side. Scarlet lake is a warm red, for example, while quinacridone rose is a cool one. I find that greens can be highly transitional—they tend to follow the crowd and go cool or warm, depending on who they are sitting by—and they are often fugitive, that is, green pigment often doesn't hold up as well as others to time or washing.

It's generally desirable for a painting to read as basically warm or cool. I'm not suggesting that you eliminate one color temperature from a painting altogether. It's a matter of controlling the proportion of one to the other. I've seen scores of landscapes pull apart at their centers because painters used a very cool blue for the sky and a very warm green for the grass—instead of staying dominantly cool or warm in both places. Ultimately, the most important rule in terms of temperature is to go ahead and try it.

Color Opacity

Some paints are more opaque than others. Mineral pigments such as phthalo greens and blues are usually clearer, more transparent than such earth pigments as Hooker's green, ochres, and browns. Cadmiums, being composites, are somewhere in the middle. They can be clear because of their strength, but can still be more opaque and often not good for subsequent washes or glazes. Each type has its merit. Mineral pigments are great for glazing; earth pigments have an opacity that's wonderful for working direct. Composite pigments can go either way, depending upon the individual color's personality.

Every color has its own personality. Get to know them. I even ascribe gender to some. I think of scarlet lake as quite an extroverted lady. She'll go wherever you put her and make herself right at home. Violet gray hardly wants to leave the tube, let alone the palette, once she's in there. Stubborn, that one—but a lovely color. And manganese blue—the way he wants to separate his sediment from water almost instantly, why he's downright schizophrenic at times!

Color Systems

Monochromatic, analogous, complementary, and primary are the four basic color systems. It's important for artists to be conscious of which systems they prefer, for it often means the difference between staying with a painting or giving up on it. Whenever I'm seeking a new statement to make with my watercolors, I always work monochromatically—almost exclusively in pink (see *Autumn Trees* on pages 18–19). Because I love that color so much, it allows me to stay with it, even when the painting isn't going well. Monochromatic color—the use of one hue with variations of value—can be very quiet or quietly dramatic.

ORCHARD IN SIENA
22 × 30" (56 × 76 cm), 1997.
Collection of the artist.

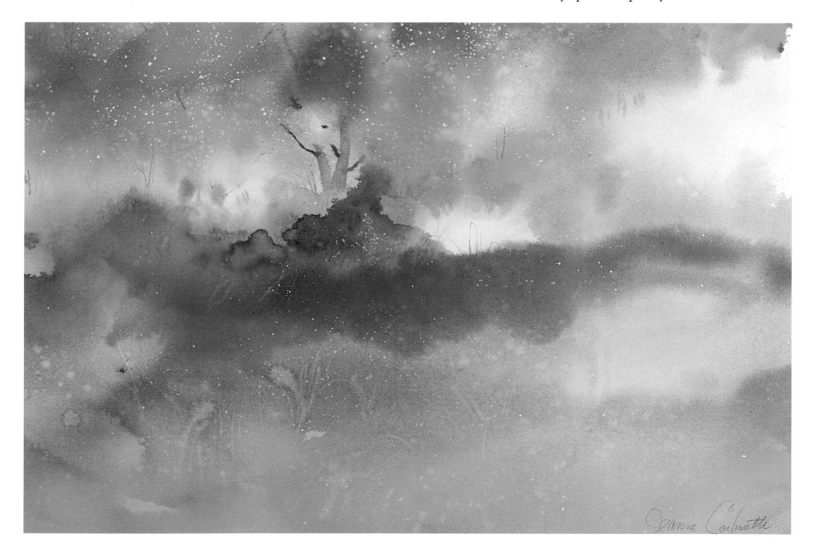

Analogous colors are those adjacent to each other on the color wheel, as in the rainbow: red, orange, and yellow; green, blue, and purple. Analogous color is subtle and softly transitional (see *Water with Lilies* on page 77). You can establish big contrasts in value, but if the colors are analogous, the transition is easy to take. All my own work is primarily analogous.

Complementary colors are of much stronger contrast because they fall opposite each other on the color wheel: red and green; blue and orange; yellow and violet. They seek to cancel each other out, thus are optically dynamic. Among the most famous paintings with strong complementary palettes are those of Vincent van Gogh. In more recent work, much Op art of the 1960s—such as a big red box on a green background—often used complementaries for head-turning effects. Complementary colors engage the viewer in a very intense experience of seeing—perfect for Van Gogh's desire to have people share his lust for life, and for Op artists to create visual illusions.

Primary colors, such as employed by Piet Mondrian in his famous grid paintings, are pure, elemental, and primal. Everything is simply there at once, nothing in priority, nothing even in relationship. This can be the most powerful, and sometimes most disconcerting, system of all. Probably that is why so few people work in primaries alone. Only masters of playfulness such as Paul Klee, Joan Miró, and children have the power to dare it.

To summarize the above principles, the most important point to remember is that no one color temperature, opacity, or system is right or wrong. It always depends upon the focus and intention of the painting. What is the story you're telling? That alone should dictate your color choices.

TUSCANY HILLSIDE
5 × 7" (13 × 18 cm), 1997.
Collection of the artist.

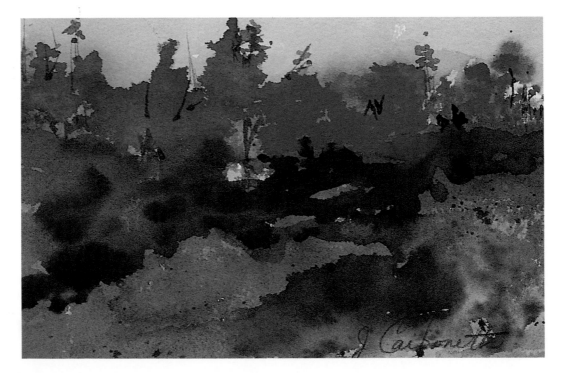

The Technique of Color Glazing

When red and blue are pooled to make purple, some of the original separate hues remain.

When a red glaze goes over blue, the purple it produces takes on added depth with the colors illuminated from below.

Glazing is the perfect way to get to know color. When I refer to a glaze, I mean color over color to impart transparency and dynamic color balance, whereas a full-body wash, which may use color over color, is intended to add intensity rather than depth. *Depth* is a key word here, for, above all, glazing gives a painting dimension. Where washes can take you back in space, providing atmospheric perspective or deep distance to the horizon, the key characteristic of color glaze is that it takes you down deep in space, into the color itself. Washes tend not to call attention to themselves, but glazes allow the paper's surface itself to have depth, much like looking down at a quiet pond and seeing the life beneath the surface.

First, glazing is a wonderful correctional device. You can bestow a whole new aura to a painting by giving it a partial glaze. Glazes adjust front-to-back dimensions, in-and-out rhythms, and the sense of planes on planes. Often when a painting appears hopeless, I give it an overall wet glaze of two colors and suddenly—life again! Some of my favorite paintings, once relegated to my rejection drawer, were thus revived.

Second, color glazing can add great luminosity and vibrancy to a painting. More than one gallery has asked me if I add some kind of gel medium to my paints, for they find it hard to believe that standard watercolors can be so dynamic.

Third, as I noted above, it bears repeating that glazing truly adds a dimension of deep space to a painting—simply because colors are literally layered on top of each other. The result is not one new color, but three: the first color, then the second, then the third that the combination produces. An example would be red glaze over blue to make purple. This is the difference from working direct with the same colors. If red and blue were pooled together, there would still be some red, some blue, some purple. But they would all exist on the same plane—a very different result indeed from colors illuminated from below.

Color can be layered either wet or dry, all over, or as partial glazes. Layered dry means that after the initial layer of color has dried, you then apply a second color, without rewetting. This provides a hard edge, giving you form wherever you need it. This method emphasizes form over fluidity. Layered wet means that you let a layer dry completely, then apply a second color, *after rewetting*. The wetter the glaze, the more conscious you should be of the personality of your paints. Some just don't like wet feet as much as others.

Contour painting—that is, painting around the shape—can be taken to new heights when joined to color glazing. The combination of the two can add a symbolic, mythic quality to a painting, not often achieved through other methods, as *Matisse's Lady* (pages 66–67) illustrates.

**MATISSE'S LADY,
SPEAK TO ME, PLEASE**
22 × 30" (56 × 76 cm), 1994.
Collection of the artist.

*By painting around a figure,
then adding glaze, watercolor
will always produce wonderfully
unexpected results, as in this
homage to a great master of color,
Henri Matisse.*

Color Glazing

Risk the big mistake. If you're not making any when glazing, you're probably not stretching yourself. Instead of playing it safe, it's better to be play*ful,* spoil a painting, and learn something valuable. You'll be a better painter tomorrow for having ruined a painting today. Other points to remember:

• Enjoy the process by expecting the unexpected and responding to it.

• In all cases, the painted layer underneath, or first wash, must be perfectly dry before starting.

• Back up. There is a dynamic balancing act going on. You need to see the big picture.

• Go stronger. Avoid chalky color, which results from too little pigment. Your paint should seem almost garish at first. It will dry at least 20 percent lighter.

• Don't judge glazes too quickly. One layer of glaze that looks too strong in the middle of a painting may provide just enough contrast that the final layer will have not only unity but dynamic power. Paintings, like children, can have their awkward stages.

A glaze that is partially wet, partially dry, gives strong lines and shapes to a painting.

A striped glaze adds texture. This was layered on very wet paper.

Top left: A diagonal glaze lends rhythm and direction. It can be layered wet or dry. Bottom left: A halo glaze, applied to wet paper, produces a lovely diffused look. Above: A drizzle glaze is perfect for rain effects. The dryer the paper, the more the paint drizzles.

Dynamic Still Life

Asimple grouping of vases can become a dynamic still life when you work around the vases with several layers of colors and shapes, then finish your painting with an overall glaze in two colors, as shown in the demonstration that follows. This is a wonderful way to use and learn about watercolor. In the Tao approach, remember to pause for a moment, close your eyes, and ask your own inner child to help you play.

STEP 1. *Working on 140-lb. paper, with light pencil I draw in three vases and two moon shapes hanging behind them. I apply my first washes of lemon yellow and phthalo crimson. Washes can be applied on dry or wet paper. In this case, I worked in combination, wetting all but the vases and moon shapes and a one-inch space around them, to ensure that I would have plenty of control as I approached the edges of the vases and moons.*

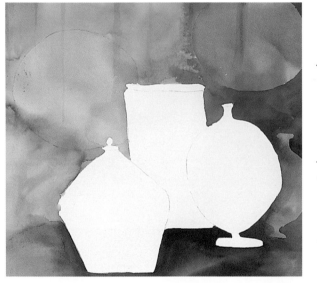

STEP 2. *After the initial washes are completely dry, for my first glaze, I apply turquoise and scarlet lake, brushing the colors on in random shapes. Note that now I suggest a fourth vase shape by painting around it (contour painting) while obscuring the moon shapes by glazing over them.*

STEP 3. *When my first glaze is completely dry, I wet the paper totally and brush on my second—mauve and quinacridone rose in a striped glaze, working from top to bottom. Then I roll the whole painting from side to side to allow colors to merge. Gently, I blot up some color from the central vase to bring out more light.*

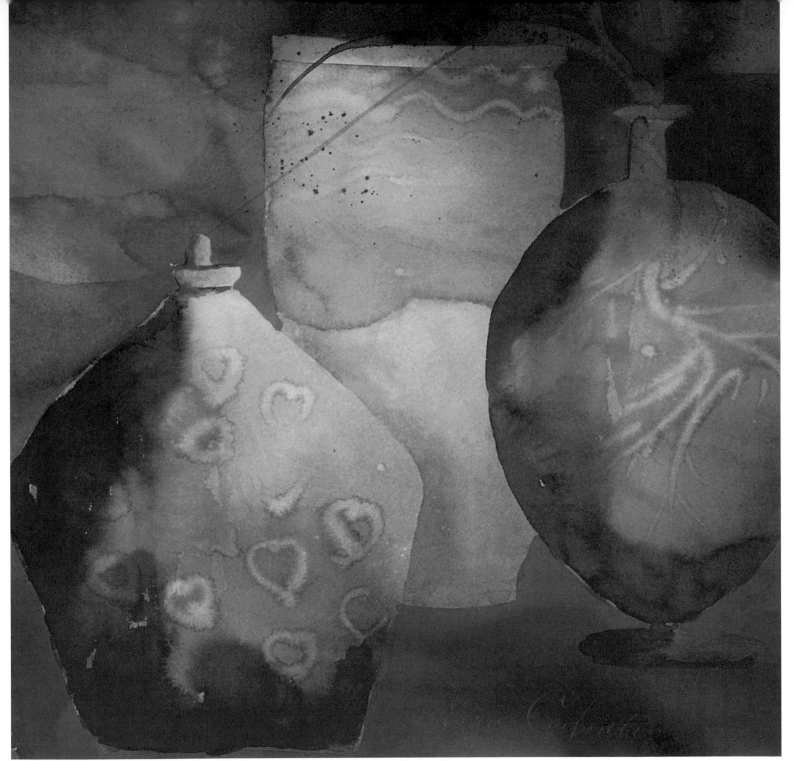

SANTA FE STILL LIFE (DETAIL)
25 × 25" (64 × 64 cm), 1996. Collection of the artist.

I add shadows, shapes, and lines, bringing the focus forward. The whiter lights that now emerge are from continued blotting as the final glaze dried. Note the vibrancy and diversity of the palette, even though only two colors of glaze were used in the final step.

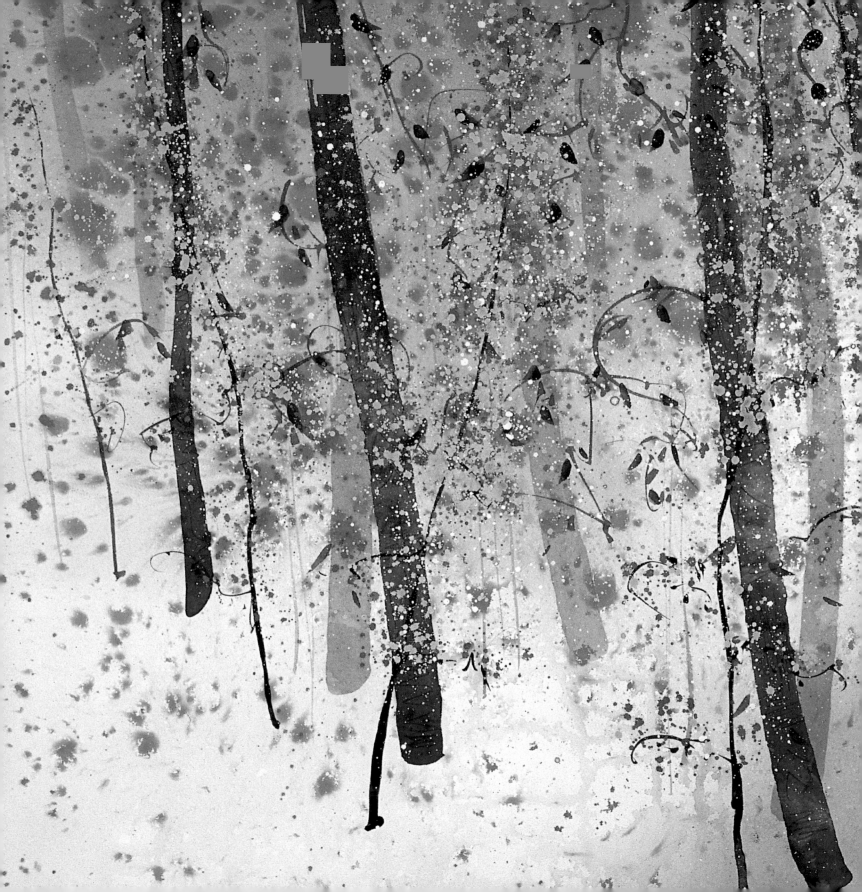

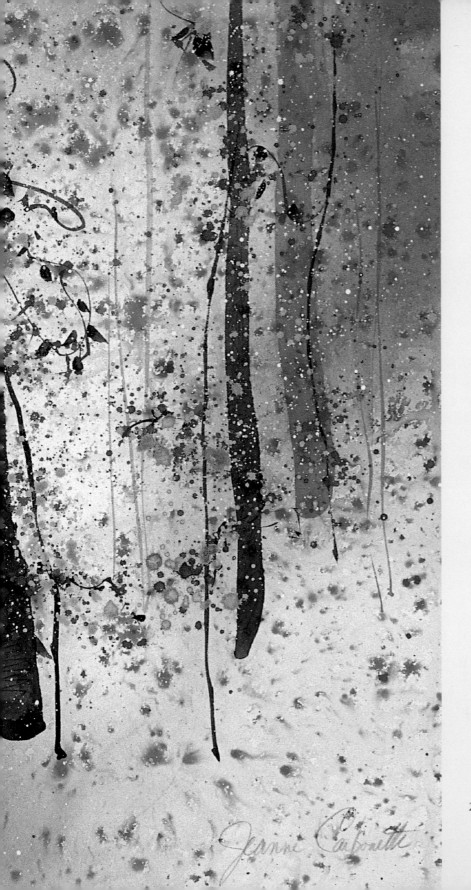

Flow

How can a man's life

keep its course

if he will not let it flow?

Tao-te Ching

FOREST IN SPRING
22 × 30" (56 × 76 cm), 1995.
Collection of the artist.

The Spirit of Flow

EXERCISE:

A Simple Reflection on Flow

Whenever you need to honor the flow of the creative process that has brought you to the moment you're in—even if it happens to be a difficult place just then—imagine this: You are standing next to a beautiful, powerful painting that you have created. You are proud of this painting. It is you. A young artist, quite self-critical, comes to you in admiration and asks, "How did you get to this place?" You breathe deeply, smile, and share the secret. "By trusting myself," you answer simply. And the young artist is filled with hope, ready to start again.

For a watercolorist, *flow* is one of the most beautiful words there is. Just to speak it seems to help the body relax its muscles, the mind to let go a little. Flow is central to Eastern schools of the inner arts, for it goes to the heart of life itself: All is one, all is flow, all simply is—and all of life is always changing. To try to resist change or control it too much is to oppose Mother Nature herself. This concept may seem paradoxical, for we might think it's safer to keep something still so it will stay where we want it—but that belies a lack of trust in the integrity of natural forms. In Eastern thought, all things within the great cosmic unity celebrate their oneness by their own special essence: How a thing is naturally is how it's meant to be; it cannot be improved upon.

Frank Lloyd Wright based his concept of organic architecture on that premise, allowing building materials to retain their intrinsic nature. Concrete to Wright was just that; its beauty was in being concrete. It becomes grotesque if we try to make it look like wood. Thus the notion of flow is important to the artist in two ways: to go with the flow of the medium's natural tendencies; and to go with the flow of the needs of the moment—for our painting, like life itself, is constantly changing.

For the Sumi-e artist, the concept of flow finds itself first in the rhythmic pacing of the painter's movements. Once the painting has begun, there is no stopping, nor is there any rushing, only a steady pace of being present and responsive. Since time flows for the Sumi-e artist, there is no "fixing" or going back to start over. There is only responding, moment by moment, to each subsequent brushstroke and to the whole, always respecting the medium's inherent nature, allowing ink, water, and paper to behave naturally. The ink can be dark, strong, and deliberate, as in foliage; the paper might give its texture to bamboo bark; the water's soft spills allow a mist to merge front to back into a middle distance of mystery.

In Tai Chi movement as well, both notions of flow operate at important levels. What is wonderful about the art of Tai Chi is that a little woman of one hundred pounds like me can be just as effective as a man twice my weight. Why? Because force is not where the power comes from: flow is. I can still remember the first time I was finally able to push a big fellow off balance, because I had learned to go with the flow of my opponent's action. He felt like a feather. Equally important for the Tai Chi player is respecting one's natural equipment. I cannot kick as high as many in my class and when I try to be like them, I lose my balance. But when I let myself play from my own range of ability, I stay in balance and can accomplish the same result.

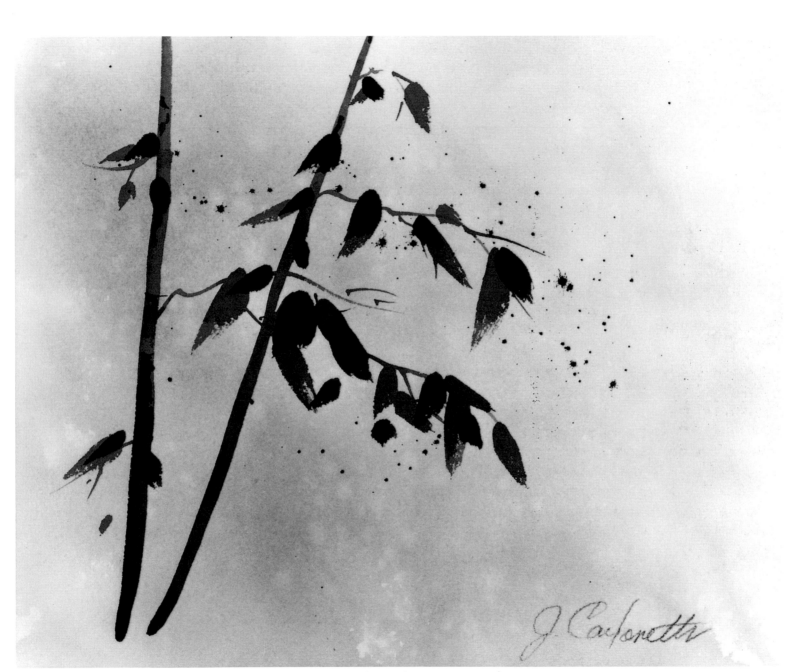

SUMI-E STUDY
8 × 10" (20 × 25 cm), 1997. Collection of the artist.

Simplicity, harmony, and the concept of flow, so characteristic of Eastern art, inspired this study. When the Sumi–e artist begins a painting, there is no backtracking or starting over—only responding to the medium's natural flow.

The Mindfulness of *Texture*

In the painter's language, *texture* means the feel of an object being painted, and the feel of the medium itself. Let's address the latter aspect of texture, for it seems to me that the feel of the medium should come first in mindfulness if a painting is to be successful.

Like the Sumi-e painter, the watercolorist, of course, also works with water. While transparency is certainly one of the two defining characteristics of the medium's integrity, fluidity, or flow, is the other. I often feel that flow is not given quite the respect that it deserves, for there seems to be a viewpoint, usually held by nonpainters, that the spill of watercolor is where the artist just "let it happen," therefore it's "uncontrolled." It looks easy, so it can't be worthwhile or demand expertise.

But most watercolorists would agree that being present with the fluid parts of the painting is where the challenge lies—to respond quickly and flexibly in order to guide the medium along its course. I think of it as a rafter going down a rushing river. You don't fight it, but neither are you relinquishing control completely. You steer the raft as it flows with the current.

As a painter of watercolors, I feel that the modulation and dimensions of the piece need to come from the medium's inherent properties—paint and water—not from drawing, which is another medium. Drawing is certainly important as it informs the placement of shapes on a page, but the application of paint, not line, should tell the story in a painting. Just how far you go with fluidity has to do with your personal vision. In my own work, I want the fluid part to be the focus of attention, really to set the stage and not be merely a background player. I like my painting to be "high noon" between abstract and figurative—the working method that feels best to me. I keep specific edges to an absolute minimum and add accents by "gelling" forms, bringing them into what photographers would call soft focus.

But how does one establish form by concentrating on fluidity? A good question, and the heart of all watercolor. Just like yin and yang, form and fluidity each have their proper place within the whole.

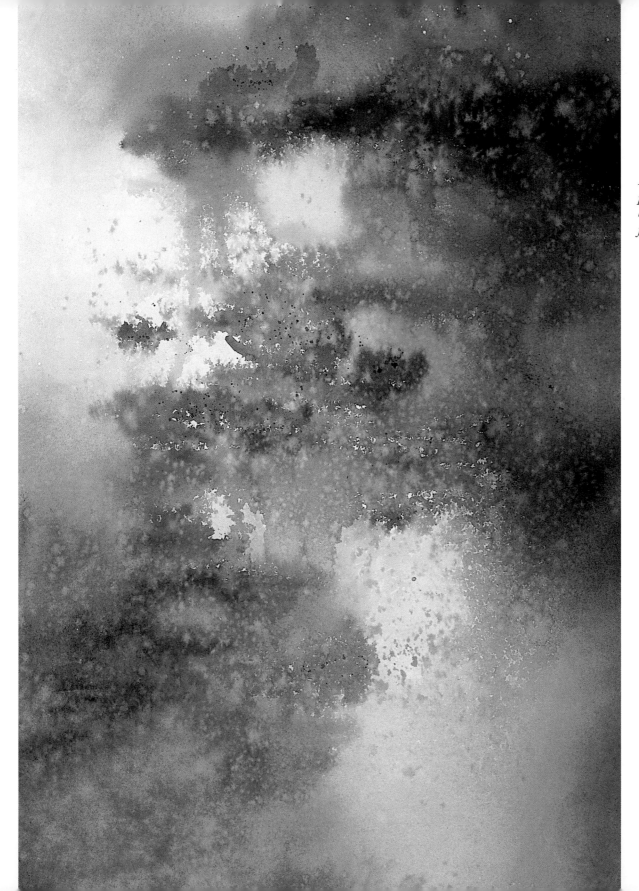

WATER WITH LILIES
30 × 22" (76 × 56 cm), 1987.
Collection of the artist.

*In this painting, the
predominance of wet glazing
creates a fluid and gelled
form without edges.*

The Technique of Wet Glazing with Soft Spatter

In the section on color glazing (see "Playfulness" chapter), I pointed out the benefits of layering pigment to show depth and dynamic color play. This rich technique may be worked on dry paper, effecting a partial glaze, or on damp paper, as with drizzle glaze, to impart some color and texture to specific areas of a painting. Even when this glazing is applied as an all-over wet technique, it aims to make a color statement, rather than a fluid statement.

Wet glazing takes the process a step further. Its goal is fluidity, working in minimal color at each stage to maximize the sense of "spill." For maximum depth, dry each layer thoroughly, then rewet completely before applying more color. Each layer flows over the rest of the painting as you direct it. The big difference between wet glazing and color glazing is worth emphasizing. While both techniques use glazes for depth, color glazing emphasizes color over flow, while wet glazing makes *fluidity itself* the goal.

I like to think of wet glaze as the *wu-wei*—the nonbeing from which all being emanates. The wet glaze for me is the essence of life just before form begins. When the story of creation in Genesis states, "And spirit moved across the face of the waters," I can't help but picture a beautiful wet glaze. There is actually much more control to this process than there may appear to be. I find the method wonderful for providing a "light from within" quality, as in the examples on the opposite page.

After the first layer of wet glaze has dried, a second color can be applied, but in lesser proportion. Wet the paper entirely again after the first wash (I often spray, rather than brush water on), using enough water to get real flow. Apply the second color slightly thicker, but be sure it's still very movable. Now forms begin to emerge. Here the paper is sprayed enough to be wet, but still has some dry openings here and there. Applying color in a slightly thicker way, some edges, though soft, are left. This helps the feeling of forms to take shape, but not too formed as to oppose the fluid parts. If you jump too fast to defining forms, you'll start to tell a different story from the one set up by fluidity. The perfect intermediary at this point is a variation on the full-body wash: the fluid body wash, which produces such specific shapes as branches and tree trunks, but still allows the emphasis to be on fluidity rather than form.

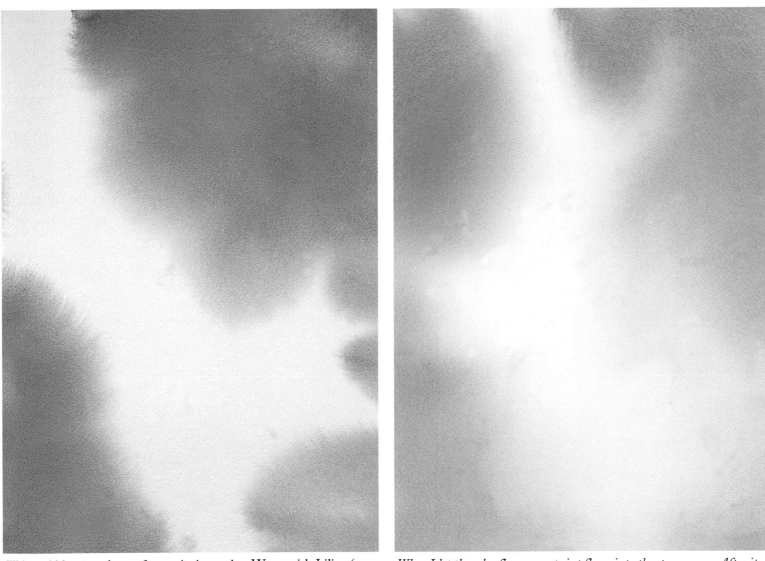

This could be an early step for a painting such as Water with Lilies *(page 77). I begin by appling color in blocks on wet paper around the area that will be a stream. I do not paint the stream.*

When I let the color flow, some paint flows into the stream area. After it dries, I have the lightest blush of color on the stream itself, which provides a beautiful soft light, as if it were coming from down under, rather than the stark white of the paper, which can flatten the picture plane and make it look blank.

At this point, spattering can contribute what it does best: textured effects without hard edges, which aids in developing forms softly. I see an inherent middle-distance quality to spattering that has a decided Oriental aura. My personal credo is, When in doubt, spatter! Akin to glazing application, spattering is built up layer over layer, each a little more specific than the one before it. Wet your paper for each layer, tamp it with a paper towel to bring it to a dampness, then spatter dots of opaque color where desired.

To review the specific mechanics of spattering: Simply hold one loaded brush over a pencil or brush end, and tap hard. You can direct your spatter by holding both brushes tightly, close to their ends. For less-directed spatter, hold brushes loosely and farther away from the paper.

Note that soft spatter brings things forward in a painting, whereas spatter wash is intended to add texture to a background. A good soft spatter will spread just a little when it hits the paper. If it moves too fast, it's too wet; if not at all, too dry. Each successive spattering done after drying and rewetting is just a little drier.

One rule of thumb: the wetter the brush, the bigger the drops; the dryer the brush, the finer the drops. I like a fairly dry brush for my final spatter. It helps merge all the areas into the soft focus I like. The *wu wei* has now become the essence of form.

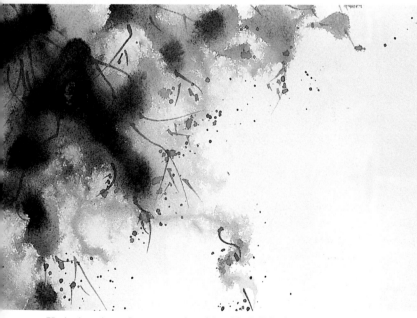 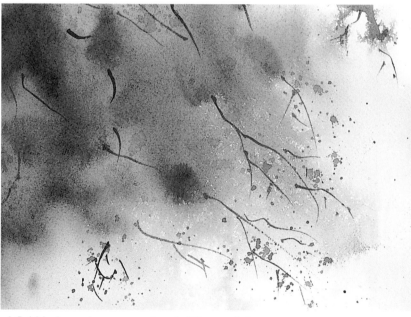

Variations in value are produced by this full-body wash over wet glaze. *A fluid body wash over wet glaze builds up soft form.*

Successive spatterings—from soft to hard, more wet to more dry—create a a beautiful sense of depth in atmospheric snow. In painting foliage, this technique creates a wonderful sense of dimension.

Summer Orchard
22 × 30" (56 × 76 cm), 1996.
Collection of the artist.

*Both wet glazing and spattering
techniques animate this summer scene.*

Wet Glazing

Have patience. Try not to get too specific too soon. Resist the urge to concentrate on one area or object in a painting; move around. As you go with the flow, you'll discover these essentials of wet glazing:

- When water drips easily off the edge of the paper, it's ready to receive wet glaze. Always wet your paper thoroughly for this technique.

- Be sure to load your brush with enough pigment. It's going to move around a lot, becoming diluted as you work.

- Drop in paint or add it next to color, *rather than brushing it in,* which will keep your hues clean.

- After each wet glaze, let the paper soak in color for a moment. This "sinking" procedure will begin to produce little rivulets in different areas, a quality to be expected in wet glazing. Simply roll the sheet around a bit to allow the color to move into another area. If necessary, I repeat this step, trying to limit it to only twice more. After that, the painting will dry too much.

- If you need to use a paper towel to soak up extra color and water, be sure to apply it with a very light touch. If you press too hard, you'll produce an edge, which will interrupt the flow. (Use a very soft paper towel for this.)

WINTER BIRCHES
5 × 7" (13 × 18 cm), 1997.
Collection of the artist.

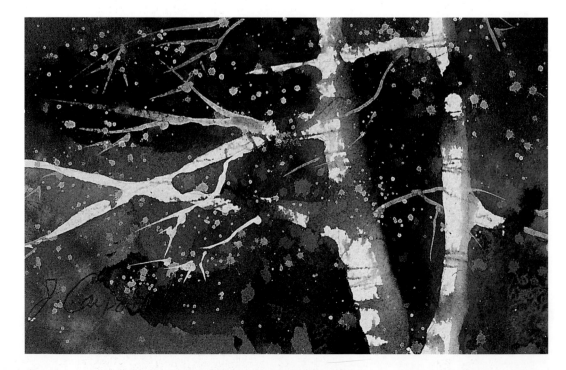

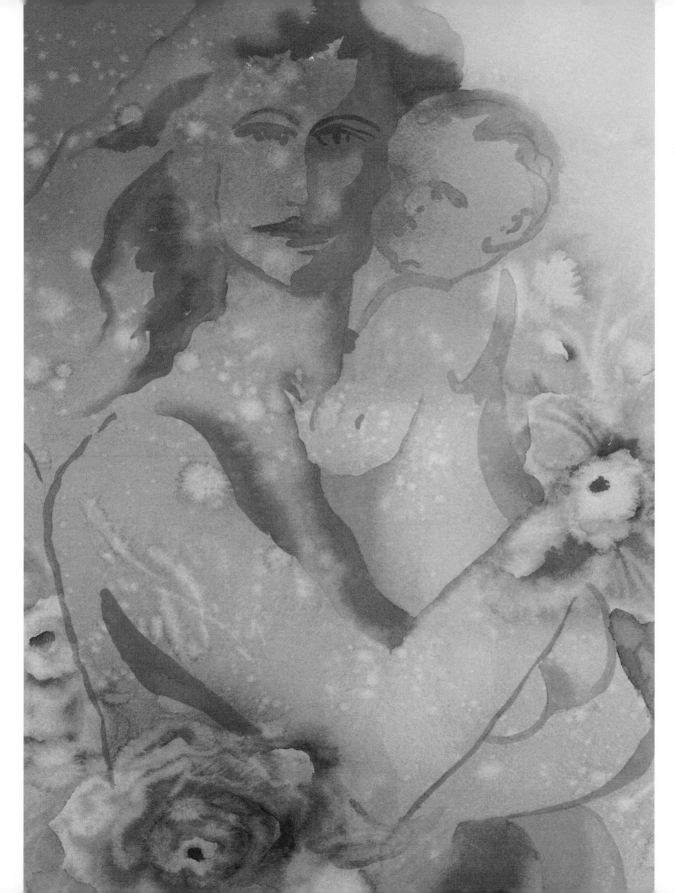

MOTHER AND CHILD
25 × 22" (64 × 56 cm),
1997. Collection of
the artist.

Things I've Learned About Soft Spatter

The key to soft spattering is timing—as is true of so many good things in life. Here are ways to judge when the time is right and how to proceed to your next step, plus several other useful tips:

- The paper needs to be just damp enough to let the paint move a little, not a lot. Try a spot. If it "explodes," it's too wet; if it doesn't move at all, it's too dry. Adjust accordingly.
- If you apply spatter to areas already painted, use a more opaque paint for coverage.
- In any kind of spattering, light can go over dark, as long as there is an opacity to it. Colors such as cerulean blue or magnesium green are opaque enough in themselves. Others can get just a little help by adding Chinese white or white gouache (opaque watercolor) to the pigment.
- Get to know which of your round brushes like to spatter; some do and some don't. Round brushes with long bristles tend not to; they flip color around so much that it's hard to direct where it lands. Large but fairly stubby rounds, #10 or #12, seem to enjoy spattering, and they gladly respond to very directed or loose, flexible spattering.
- For directed spattering, hold both your brush and the tapping instrument (I use a pencil) very tightly, very close to the end, and very close to the paper. That's the secret to getting it to land where you want it. For less-directed spatter (such as snow), hold the brush and tapping instrument loosely, midway on their handles, and up high off the paper.
- Remember, the wetter the brush, the bigger the drops of spatter; the drier the brush, the finer the drops. It's amazing how much variation subtle changes in pigment and wetness can make. You will get to know them by experimenting.
- Bring colors from the background forward with spattering. This gives unity to the painting.
- Be careful not to overspatter. Back up from your painting enough to see the big picture. I can often be overheard talking to myself at such times— "Don't overdo, Jeanne"—since I love spattering as much as wet glazing.

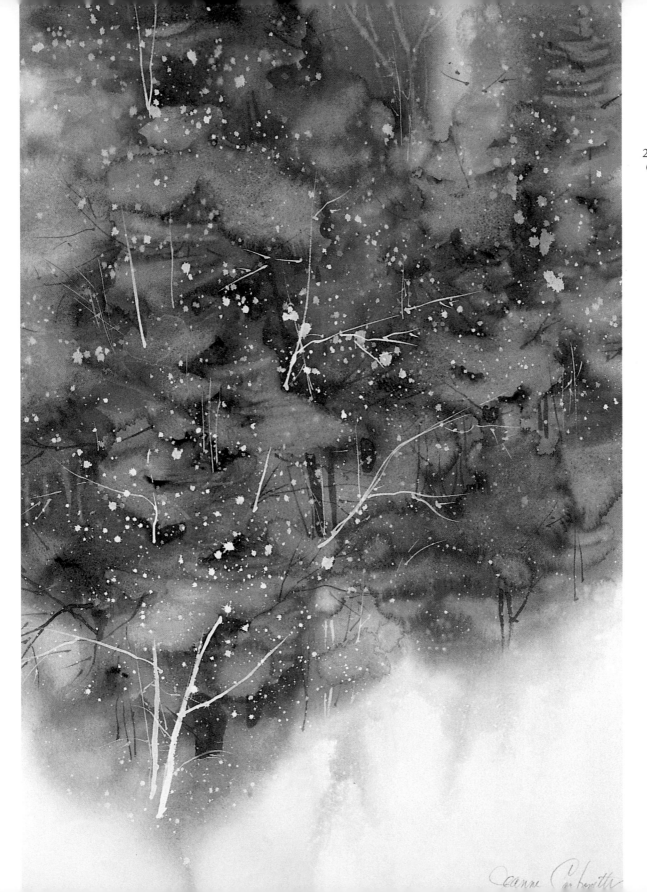

Magic Mountain
26 × 20" (66 × 51 cm), 1996.
Collection of Steven Gunn.

Flowing Landscape

Creating a landscape based on this demonstration will give you an opportunity to practice both wet-glaze and soft-spatter techniques. Whether you use my palette or choose your own colors, if you follow the step-by-step process outlined, I'm sure you'll enjoy seeing—as your work evolves from nonbeing to being, just as the Tao promises—how a beautiful landscape emerges.

STEP 1. *On 140-lb. cold-pressed paper, I begin by spraying the sheet with water. I block in color and let it flow spontaneously, using a one-inch mop brush loaded with mauve, my first color, allowing it to flow over the paper. I hasten drying with a hair dryer just a little, in order to help the first color "sink," then I introduce turquoise, my second color, responding to it and adjusting my abstract composition as I proceed.*

STEP 2. *Now I add a fluid body glaze of phthalo blue, allowing it to flow over the other colors, with emphasis in chosen areas to impart that bit of thickness and texture that will give body to foliage—but I'm still not concerned with being too specific in defining particular forms.*

STEP 3. *Now the painting begins telling me where trunks and branches will go. After drying the paper again, I add a glaze of phthalo green, but only to selected areas.*

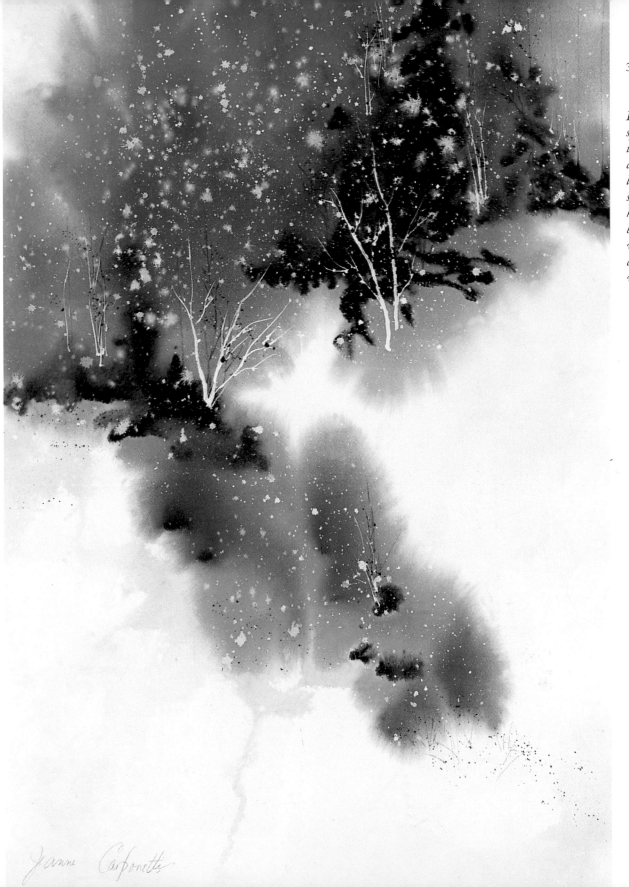

CROW HILL WINTER
30 × 20" (77 × 51 cm), 1996.
Collection of Bernard and
Judy Stebel.

I apply a succession of three spatter layers from soft to hard, dampening and drying each time. I usually like to make my finest, last spatter the lightest. Note how softened the colors become as I spatter Chinese white. The thin tree trunks and branches are applied with a fine # 5 rigger brush.

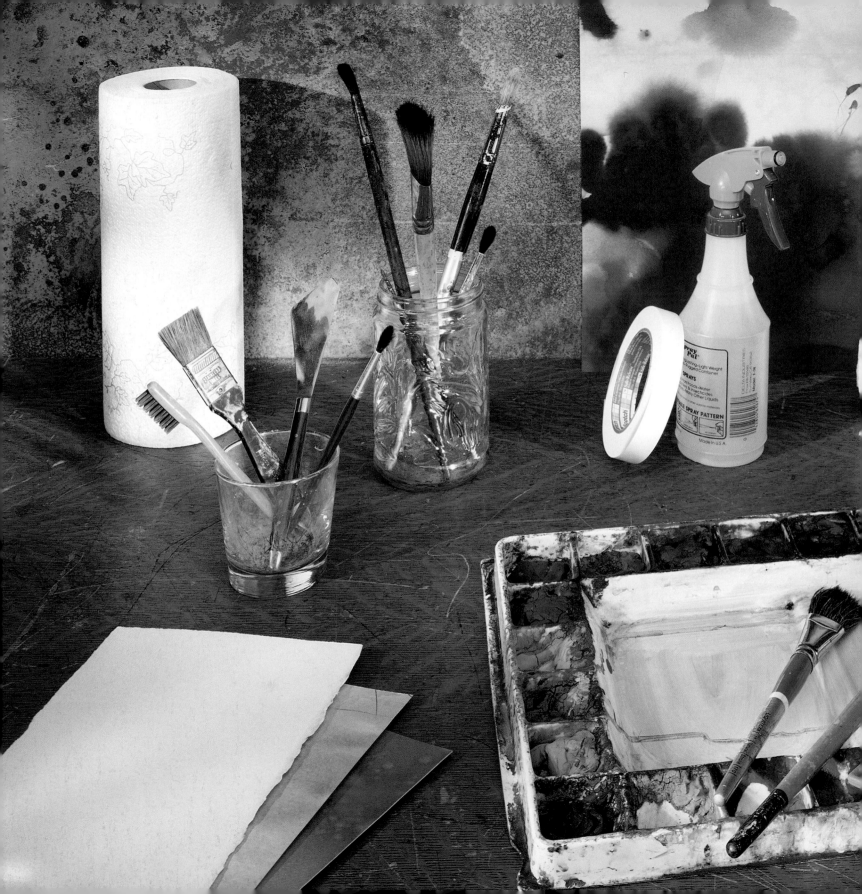

The Tao of Tools

Thus we are helped

by what is not,

to use what is.

Tao-te Ching

*My favorite painting partners—
palette, colors, brushes, papers,
water mister, tape, and towels—
always await me in my studio
to brighten my day.*

The Spirit of Partnership

I believe that painters can enjoy a relationship with the tools of their trade that truly increases the flow of creative inspiration, as opposed to viewing materials only as vehicles of communication. It is a spirit of partnership. We painters love our paints, brushes, and papers. The process itself—whether or not it produces a wonderful painting each time—is seductive, and it is this attraction to the materials themselves that keeps us coming back to the table, even when painting itself can be difficult.

Sometimes it can be. As we grow as artists, the need to go deeper becomes greater. We are ever seeking new forms to fit what is more intangible. I'm sure this is what drove Georgia O'Keeffe as she spent two years paring down her marks until she arrived at the single thin line—an abstraction that she felt was the only thing that could accurately describe her feelings. It's the same impetus that led one of my longtime students, who became an award-winning abstract painter, to tell me, "Five years ago you said that after all the techniques were learned, it would get harder. I didn't believe you then. Now I do."

The creative process can take watercolorists deep into new territory when we don't know what to paint or how to paint it. At such times, materials themselves can help us. Allowing ourselves to respond to nuances that occur unexpectedly because of the way the water moves across a page, or a certain kind of paint behaves, or even the way a paper takes the humidity that day—all those things help us to stay within the spirit of playfulness, to play rather than control, to engage rather than dictate.

If we put ourselves there at the table and keep at it, the muse will always speak. Allow your tools to do what they do best. Respond to their invitation, and with knowledge of technique behind you, the process is sure to be one of great discovery and joy.

Let me share with you some special features of the watercolorist's most important materials. But first, here's a minimal list of most useful basics:

- Paper: 140-lb. cold-pressed paper
- Tube watercolors: red, yellow, blue, green, Chinese white
- Brushes: rounds #5, #10, #20, ³/₄" mop brush, #5 rigger
- Palette
- Board to hold paper, 24 × 32"
- Masking tape
- Paper towels
- Mister for water
- Water jar
- Hair dryer

Paper

I recommend 140-lb. cold-pressed watercolor paper as an excellent support to work on, especially for beginning painters. Cold-pressed paper, which has some tooth (slight roughness) to it, allows for a faster absorption of paint than smooth, hot-pressed paper. Cold-pressed also dries more slowly, thus giving the painter added thinking time. For thumbnail sketches, 90-lb. paper is good but doesn't hold up well under very wet, repeated washes, and seldom lets you use the back for another painting. On the other hand, 300-lb. paper certainly accepts thorough wetting, but unless you wish to scrub out a lot or work very large, you won't need such a heavy paper.

A reliable paper choice for beginning watercolorists and experienced artists alike is 140-lb. cold-pressed. With a few tube watercolors and some basic brushes, you're all set to begin.

On 140-lb. paper, the rivulets that form keep me mindful of texture. And when I flatten a sheet with my hands as I use a hair dryer on the paper, my pacing slows to a steady rhythm. In terms of brands, my favorite is Arches, but I often play with other papers to see what they have to offer. I recommend that you experiment, too, and follow your own instincts.

Sometimes I do use hot-pressed paper when I want a watermark to show up and colors to have more of a spilled look than a merged look. Hot-pressed paper suits these aims, as it allows paint to sit up on top of paper longer than on a cold-pressed surface.

Watercolorists often soak paper before painting on it, in order to remove sizing—a substance used in the manufacturing process to stiffen paper. I find that it makes paper too absorbent for my taste. Since stretching and stapling paper to keep it from buckling are not as important to me, it seems an unnecessary step. For me, the buckling itself has become a part of the *Tao* of the paper, so I try to watch what it can show me—but it does demand that I watch carefully while it dries.

Brushes

My personal favorites are two #12 round, red-sable watercolor brushes that are present at all times, along with a #10 round and a #7. The two #12 rounds serve as perfect painting and wetting partners, particularly during the technique of blended-wet painting. The #10 round often serves as an "extra color helper" for dropping in dollops of pure color to add drama. I have used these brushes for twenty-five years, and they're still wonderful, so I consider the initial investment more than economical by now. A good round brush, whether red sable or sabelline, has two important qualities: It comes to a nice point when wet; it won't collapse even after several brushstrokes. A brush should always be resilient and bounce back. This allows you to keep it plump with color and to do fairly detailed work. For delicate line work, I've found that a rigger—a brush with flexible, elongated hairs that come to a very fine point— is ideal, so I don't need to have several very small rounds on hand. The rigger's versatility allows for wide or thin lines, graceful or angular, just by altering how it's handled.

Along with my rounds and rigger, my mop brush is essential. I have both a 1" and a 3/4" on hand, and they're perfect for patting in color when I want to avoid being fussy. The mop allows me to lay color on the paper without rubbing it in. This helps keep my color clean, not "pawed."

Another brush with special qualities is a flat wash brush with a beveled handle. The tip is just right for those hard-to-get-at sharp edges needed in contour painting. When depicting trees, the beveled edge is handy for scraping out trunks and branches or digging to get darker lines in wet paint.

In summary, if I were left on an island with a choice of only six brushes, they would be 2 large rounds, one medium round, a rigger, a mop, and a flat wash brush. As long as I'd have paper, paint, and water, I'd be just fine.

Paint

The essence of paint has more to do with its texture than with its hue, or even its lightfastness. As a material that needs to be spread and mixed, paint must feel comfortable and have the pliancy of liquid. Here is where the greatest differences lie, not only among pigments themselves, but among various brands. It really comes down to how you work with the paint. Some highly acclaimed brands are just too rubbery for me to use quickly. I must spend too much time working them out of my brush, and since my paintings are usually large and bold, I don't have time to stop when I'm in the heat of it. Other paints are too plastic for me and I seem to need much more pigment to get the richness of color I need. My own usual palette contains a combination of paints from Sennelier, Holbein, Grumbacher, and Winsor & Newton, and I've found that so-called student-grade pigments often have just as good qualities, including colorfastness, as more expensive paints.

ORIENTAL LILIES
22 × 30" (56 × 76 cm), 1993.
Collection of the artist.

The pink petals in this floral became more animated as soon as I added accents of rich red. Value contrasts like this lend instant vibrancy to a watercolor painting. My palette here includes lemon yellow, phthalo crimson, phthalo yellow green, phthalo green, and turquoise.

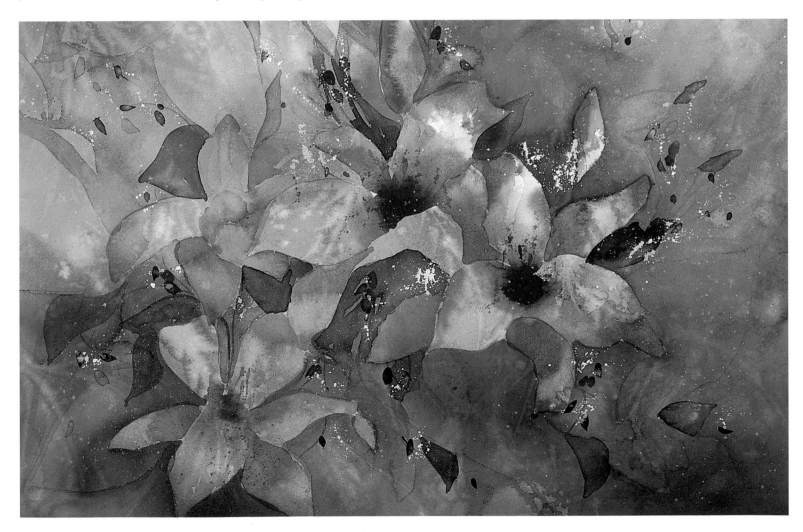

My most basic, specific color choices now are a combination of very clear (mineral pigments) and more opaque (usually composite) pigments:
- Reds: phthalo crimson, quinacridone rose, scarlet lake, cadmium red
- Yellows: lemon yellow, cadmium yellow medium, cadmium yellow dark
- Blues: phthalo blue, turquoise, cerulean blue, cobalt blue
- Greens: phthalo green, phthalo yellow green, magnesium green
- Purples: mauve, phthalo purple
- Orange: vermilion

To get earth tones (which I seldom use now) such as ochres, browns, or moss greens, I mix my colors, but generally I prefer to work straight from the primaries for initial washes and glazes, then add other colors for adjustments.

Other Tools

The drawing board that holds your watercolor paper is another important painting partner. In my earlier list of basic materials, I included a 24 × 32" board, and suggest that you might want to have a second one as well—16 × 20", a handier size for smaller work. The boards I use, which I place on my worktable, are single-ply plywood chosen for lightness in weight. I tape my paper to the board so that I can lay color on flat but then am able to move the board around to direct flow.

Some artists use pushpins or bulldog clips to affix their paper to the drawing board; I prefer tape, but I'm careful to choose one that won't tear my paper's edges when it's removed. A safe choice is 3M masking tape.

What Other Mediums Can Teach You

I'm often asked if I ever get tired of watercolor. "No, never," is my truthful response. I did paint with oils and acrylics as a child, but when I tried tube watercolors for the first time in junior high, I knew that was it for me for this lifetime. The fluidity and transparency of watercolor seemed to say, "I am you." But there are moments when I'm intrigued by what might happen by joining watercolor to another medium. So a wonderful large box of pastels on my counter has led to some pleasing experiments that have actually given me a greater understanding of my thematic work. I've done this with Sumi-e inks as well. I love the ink bars, and the brushes entice me with their beautiful handles. But soon I'm back to my pure, simple watercolor. I never feel guilty. Every small affair with other materials helps me to know my own medium even better, and I learn anew that it is watercolor that is the love of my life.

Sumi-e brushes and ink bars are appealing materials to work with, as are luminous pastels. You may find, as I have, that by experimenting with other mediums, and perhaps trying mixed media, your understanding of watercolor painting will be enhanced.

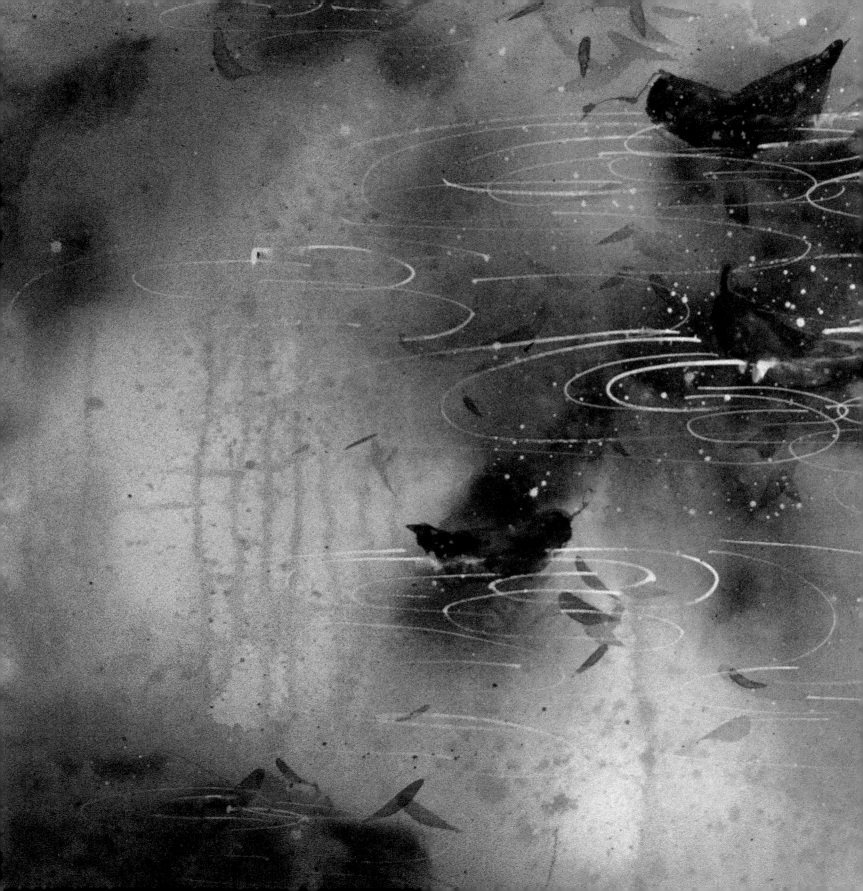

Effortless Effort

The master views the parts

with compassion,

because he understands

the whole.

Tao-te Ching

SUMMER LEAVES ON WATER
22 × 30" (56 × 76 cm), 1987.
Collection of Diane and
Eric Friets.

The Spirit of *Effortless Effort*

I will never forget the experience that made me trust implicitly the power of the creative process. I have not been the same since that time. It was just after my husband and I had finally made our move to Vermont.

For three years, we had commuted from New Jersey (a five-hundred-mile round trip) every weekend while we built our home with our own bare hands. While I had continued to paint during that time, it was really just my hands working, without my head and heart. By the time I landed in Vermont, I was frightened that I might have lost what I had ever learned. But for the first time ever, I was just too exhausted to be judgmental. That first winter in Vermont I simply allowed myself to play, to get to know the paint and paper again. I worked in what seemed a most haphazard way: one day large, the next day small, one day very loose, the next day very tight and dry. The only common denominator was that everything looked awful! But I was just too tired to criticize myself. I was glad to be moving paper and paint and not two-by-fours. For once, I let myself off the hook. I would just play, no matter what.

As March came in, something in me began to stir. I started to have an idea of what I was after; it had to do with *spill* being the carrier of the story. I grew more excited and less tired, even though the paintings still looked awful. It didn't matter. They were speaking to me now; I had heard them.

On the first day of spring, I completed my breakthrough painting for what became "The Spill Series" and the start of my working in long, thematic groups of paintings. As I looked at this beautiful painting on the floor of my studio, I was awed. It was completely me, just what I was after, but I hadn't known it before. I could only tell now that it was out there. How had it happened?

I suddenly had the impulse to run to my "rejection drawer" and pull out my winter's work. There it was, step by step—the paintings had been leading me by the hand to the final work. It was so clear to me now, like a kaleidoscope that finally clicks into place when the image goes from chaos to beauty. I haven't been the same since that day, and over the years, I only grow more confident in the perfection of each person's creative process.

Two elements are of primary importance in this process. One is nonjudgment and the other is patience. Because there is always a bigger picture beyond the immediate painting at hand, I now know that there is very little value in ever judging our work. Clear perception and discernment, yes, for such dialogue with the painting can guide us further. But judgment that concludes, "I'm a good painter," or "I'm a bad one," isn't valid in this process. Now I know that when I'm painting my worst, I'm becoming my best.

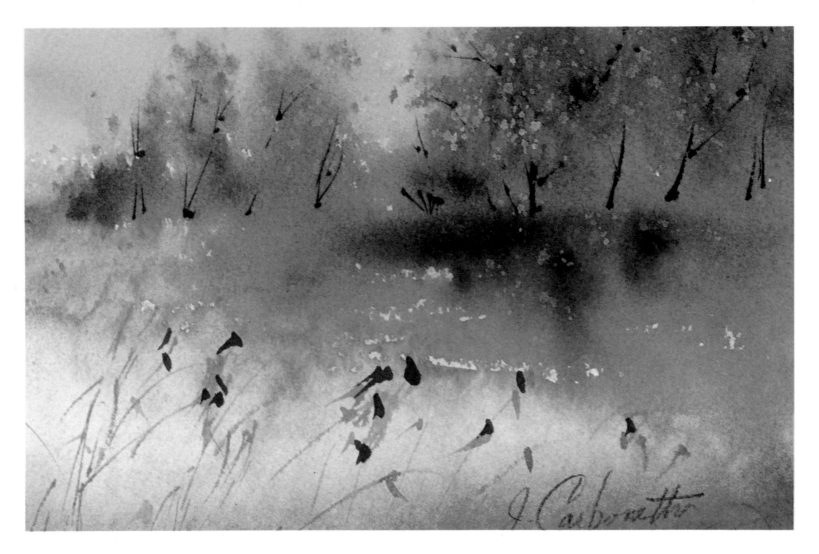

OCCUM POND
13 × 16" (33 × 41 cm), 1996.
Collection of the artist.

One of the most beautiful aspects of Tai Chi and Sumi-e is that it looks so simple and effortless, so natural. After studying either, we begin to realize that simplicity is the other, distant side, of complexity. After we've moved through the complex workings of a craft, the essence begins to emerge and we know it as our own.

Permit me to refer again to playing and why I take it so seriously. It's the place where we allow ourselves to experiment and explore, getting to know our medium and the subject, without judgment. Take that childlike innocence by the hand gently and coax it out softly, for it alone holds the power of the artist in you.

FIELD OF IRIS
22 × 30" (56 × 76 cm), 1996.
Collection of the artist.

In painting a gorgeous field of flowers, instead of trying to depict each blossom realistically, I'm more concerned with allowing luscious colors to work their magic in describing nature's lushness.

Conclusion: The Practice of Painting

If modern man would use it,

he could find old wisdom

in his heart and clear his vision

enough to see from start to finish

and finish to start,

the circle rounding perfectly.

Tao-te Ching

CHERRY TREES IN SIENA
22 × 30" (56 × 76 cm), 1997.
Collection of the artist.

The Sacred Mystery

The time I've spent with the creative process and its natural cycles has taught me to trust it implicitly, for it truly is "the circle rounding perfectly." The creative process itself is the perfect dance of yin and yang, of receptive and active, molding from nothing a new form, then moving back to formlessness to await the next vision and spark of life.

When we can truly be with ourselves in the practice of painting, we feel this instinctively—that special moment when we have discernment but are without judgment, when we have "vision," but are without expectation, when we are playful, yet hold a reverence for the sacred mystery of the creative process.

The experience takes me to the core of myself, and there the wall of separateness is broken. I am one with all the world. Just how it happens, I don't know; that's the mystery. But it is transcendent, that I do know. I simply have to be willing to be there, doing my job—painting.

How can you get to that place, where the world of work and play become one? It comes down to viewing the painting experience as a sacred one, and if you open yourself to it, I believe that your growth as an artist is assured. There may be some reading these pages for whom the more Western intention works well—concentrating wholly on technique. But in my own experience as a painter and teacher, more often than not I have seen the Eastern approach help the struggling painter. While concentrating on technique works well for a time, making that leap to find your personal style and clarify your own vision depends on stretching beyond technique. I hasten to add that it's perfectly all right if you don't feel the need to identify a personal style or special vision, even though it is somewhere within you. But most artists I've known do feel that need at some point, and then the only way to grow is by facing oneself.

Seeing your painting as a practice of self-exploration doesn't mean analyzing yourself by the marks you make on paper. It means opening yourself to the mysteries of the whole you, allowing parts of you that are often hidden to the world to surface through the practice of painting. What emerges naturally, even organically, then turns every painting into an act of discovery, and the partnership of painter and medium more easily becomes a dialogue. Each painting begins to be a mirror of a larger self than you had expected. Once the self is present, all the specifics of personal technique, style, and vision fall into place.

With every painting, we, like Narcissus, stand over a pool of self-reflection. And if we look long and hard enough, we too will see the truth: that we are beautiful, after all.

I wish you well.

MOON ON WINTER HILL
22 × 30" (56 × 76 cm), 1997.
Collection of the artist.

Suggested Bibliography

For more information on the *Tao-te Ching* and Sumi-e art, here are the books I've found most illuminating:

Bynner, Witter, translator. *The Way of Life According to Lao-tzu.* New York: Capricorn, 1944.

Mair, Victor H. , translator. *Tao Te Ching by Lao-tzu.* New York: Bantam, 1990.

Sato, Shozo. *The Art of Sumi-E.* New York: Harper and Row, 1984.

For more information on understanding the concepts of beginner's mind, centering, balance, deliberateness, playfulness, and flow:

Kent, Corita and Jan Steward. *Learning by Heart: Teachings to Free the Creative Spirit.* New York: Bantam, 1992.

London, Peter. *No More Second-Hand Art: Awakening the Artist Within.* Boston: Shambala, 1989.

Cameron, Julia. *The Vein of Gold: A Journey to Your Creative Heart.* New York: Tarcher/Putnam, 1996.

For more information on watercolor painting:

Andrews, Don. *Interpreting the Figure in Watercolor.* New York: Watson-Guptill, 1986.

Dobie, Jeanne. *Making Color Sing: Practical Lessons in Color and Design.* New York: Watson-Guptill, 1986.

Nechis, Barbara. *Watercolor from the Heart: Techniques for Painting the Essence of Nature.* New York: Watson-Guptill, 1993.

Page, Hillary. *Color Right from the Start: Progressive Lessons in Seeing and Understanding Color.* New York: Watson-Guptill, 1994.

Reid, Charles. *Painting What You Want to See.* New York: Watson-Guptill, 1983.

Reid, Charles. *Pulling Your Paintings Together: Composing With Line, Color, Mass, and Rhythm.* New York: Watson-Guptill, 1985.

Daybreak in Pienza
30 × 20" (76 × 51 cm), 1997.
Collection of the artist.

Index